FULCO SANTOSTEFANO DELLA CERDA
lived at the Villa Niscemi until the age of
thirteen, but after his grandmother's death the
family moved to the Palazzo Verdura within the
city of Palermo. He fought for his country
in the First World War and on the death of his
father in 1924 succeeded to the title of Duke of
Verdura. In 1929 he began designing materials
for Chanel and later designed semi-precious
jewellery in gold and enamel for that famous
house. He then moved to America where, by
1937, he was designing jewellery for Paul Flato.
Two years later he started his own jewellery
business on Fifth Avenue, New York, which
was to become very successful.
In 1973 he returned to Europe, where he
remained until his death in 1978.

The Happy Summer Days

A Sicilian Childhood

by Fulco

'... with many a strange tale, perhaps even
with the dream of a Wonderland of long ago;
and how she would feel with all their simple
sorrows, and find a pleasure in all their simple
joys, remembering her own child-life, and the
happy summer days.'

<div align="right">Lewis Carroll, Alice in Wonderland</div>

Weidenfeld & Nicolson
LONDON

to Maria Felice
who shared with me those joys and sorrows

First published in Great Britain in 1976 by Weidenfeld & Nicolson.
This edition published in 1998 by Weidenfeld & Nicolson.

© 1976 Fulco di Verdura

A CIP catalogue record for this book is available
from the British Library.

Printed and bound in Great Britain by
Butler & Tanner Ltd, Frome and London

Weidenfeld & Nicolson
The Orion Publishing Group Ltd
Orion House
5 Upper Saint Martin's Lane
London WC2H 9EA

Contents

Illustrations

Foreword

In all honesty I must advise the reader that here and there in this book I may have committed an error. Having no notes or diaries to consult, and most of the dramatis personae being dead, I have relied only, with the help of my sister, on my own memory, and this is what I remember.

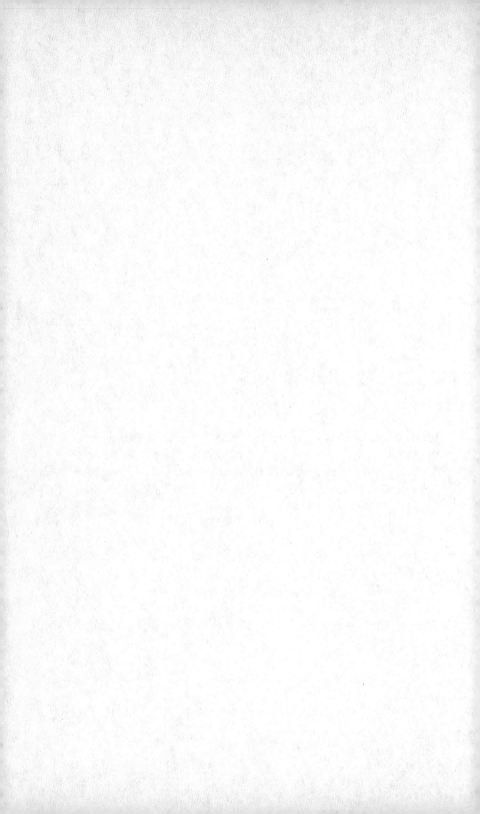

1

THE HOUSE is still there, thank God, the same dear old villa, smothered in bougainvillaea, bulging with balconies and protrusive terraces, sunbaked and tired but proudly standing in its semitropical English garden – that same garden that seemed long ago so mysterious and vast in the brown eyes of a sturdy little boy with fat legs, but now to the much-travelled eyes of this old man, shrunk in size and despoiled of its mysteries.

But the house (and for me it will remain what it has always been – 'The House' – the only house I have really loved, with the love that knows no reservations and that only a child can harbour) has lost nothing of its charm, fascination and strange power over me. This is perhaps because I remember it with the unclouded eyes of childhood; I have seldom revisited it, and have never lived in it again.

At any rate there she stands (in my intensely Italian mind a house is feminine, *la casa*, *la villa*, just as a garden is masculine,

il giardino), solid as ever, flanked by two square terraces thrust forward like open, inviting hands. From these terraces you can see, shimmering in the summer haze, the distant pinnacles and domes of Palermo surrounded by those stark russet mountains that seem to defend, like a giant rampart, that ancient royal city, once the capital of the Kingdom of the Two Sicilies; the first seat of the royal crown and the head of the kingdom. The large valley which surrounds it on three sides, the fourth to the north being the sea, is known as the Golden Shell, La Conca d'Oro, as it consists mostly of orange groves. The villa is about seven or eight miles to the west of Palermo in a region called I Colli, roughly half-way to the Bay of Mondello where we used to go to bathe. It was not really open country even then, as we were near the suburbs of Partanna, Resuttana and San Lorenzo, but we had the good fortune to be next to the great royal park called La Favorita. A gate to the right of the villa led directly into it and we could use the park and its formal gardens even when they were closed to the public; a privilege which we took absolutely for granted.

Beyond the park, less than a mile away, loomed the towering cliffs of Mount Pellegrino, salmon-pink against an incredible blue sky that some days you felt you almost could poke a hole in. This singular mountain, or rather 'the most beautiful promontory in the world', as Goethe called it, with its caves, its history and prehistory, and its memories of St Rosalie, influenced our lives with its omnipresence, casting over us all its spell of legend and mystery. Its name will recur frequently in the pages to come.

But, before we enter the house, let us go back to the garden and walk to the left along a pepper-tree-lined alley to another gate, twin to the first one. Through it lay an empty space, like a village green that was anything but green. Our garden had roughly the shape of a scalene triangle, the shortest side running behind the villa and the longest away from it towards the east. At the three points were three gates and three porters' lodges; the north one next to the villa was the one that gave access to the park that I

have mentioned, the south one at the end of the alley bordered with pepper trees looked towards I Colli and the village of San Lorenzo, and the third, the furthest away, opened on to the road outside La Favorita and led to the Piazza Leoni, or Lion's Square, and to Palermo. It was a nineteenth-century, romantic garden and there was little co-ordination in its planning, but its great charm lay in the variety of semi-tropical trees, auracarias, different kinds of gum, very tall palms and chubby palmettos, magnolia grandi-flora and hibiscus. There was a marble fountain full of papyri, an artificial grotto and, supreme attraction, a small lake with a rocky island in the middle: enough to turn any child's head.

Alongside the house there was an orchard surrounded by a high wall. You entered through a creaky green door and found your-self in a secluded ever-changing garden of Eden, filled with fruit trees, oranges, lemons, tangerines, cherries, peaches, apricots, quinces, Japanese medlars, the typical Sicilian citrus called *lumia* and a great variety of vegetables. So that with the changing seasons there was, except in the dead of winter, always something to be devoured and give one tummy-aches afterwards. The really fierce ones were caused by excesses of white cherries and figs, those delicious green figs that are blue inside, which need to be eaten skin and all, with a little drop of honey, when they are still warm from the sun. Tomatoes also have a different taste if eaten the moment they are plucked from the plant.

In the middle of this 'sanctuary of Pomona', there was a strange ancient-looking tree, its trunk gnarled and rugged, its branches all twisted. Nevertheless it bore fruit. Big, round, lemony-looking things that were supposed to be uneatable, while the flowers, waxy and white, looked like giant *zagara* (the Sicilian word for orange blossom). The gardeners called it *pampaleone*, a name that added to its tropical charm. As you may have guessed, I couldn't resist the temptation of tasting the forbidden fruit. It had a strange bitter taste that seemed to make my teeth shrink; I threw it away in disgust. As always, I was reprimanded and told that, for all I knew, it might have been poisonous and that Pipitone, the head

gardener, knew what he was talking about when he advised me not to touch it. Well, many years later, recalling this forgotten incident, I realized that this dangerous, acidulous fruit I had dared to taste was quite simply the dear old reliable grapefruit. Nobody in those days, at least in Italy, had heard of a *pompelmo*, for such is its name in Italian: it had not yet crossed the Atlantic, invaded the breakfast tables of Europe cut in half with a cherry on top or become, when you can't think of anything else, a useful first course (but without the cherry, I hope).

But now for the house itself. For all my early memories of myself, my family and my friends are inextricably entangled with the place where they happened: the looming presence of the house overshadows all. Even today, I can still conjure up its feel and its smell, the cool, dark texture of the rambling rooms on a hot day: the sense of high ceilings, frescoed walls and endless space.

The house was a big, early eighteenth-century structure, not exceptional – there were more spectacular villas around Palermo – but it had a warm, sympathetic charm of its own that I have seldom encountered in other houses. The rather mediocre frescoes are still there as they were then, but in my day the furniture, except some 'set' pieces, had no pretence to anything but comfort and solidity and one could bounce on sofas and pouffes to one's heart's content – provided, of course, that no grown-ups were in sight, which was fairly easy as it was quite a big house.

One of my oldest memories is waiting for Grandmamá and Mamá to come back from their daily visit to Palermo. At seven in the evening the big gates of La Favorita would close; as Grandmamá and Mamá never came home before eight, they had to use the third gate at the bottom of the garden. I can still hear the noises of the landau that was bringing them home. First the distant rumble approaching, then, in an alarming crescendo, the machine-gun-like fuses as they crunched over the gravel drive and the booming finale as carriage, horses, coachmen came to a resounding stop under the *porte cochère*, or covered porch, to deposit the two ladies and their parcels.

4

From whatever part of the house we might be in, my sister and I would propel ourselves to the entrance hall screaming 'Hojoho-ho' in the best Valkyrian fashion at the top of our lungs, followed at a distance by a highly-disapproving but impotent governess and a bevy of yapping dogs, and then we would hurl ourselves into the arms of the two most beloved personages in our lives as they emerged into the hall.

This was a vast, impressive room full of the most seductive possibilities for a child, from the marble floor for roller-skating to the enormous birdcage full of exotic tiny birds and the grumpy old parrot, Coco, always willing to take a nip at any part of one's anatomy that came within the range of its beak. Between two balconies that looked on the garden was a monumental 1880 renaissance chimney-piece, complete with lions' heads and lions' claws, garlands and festoons of pulpy things that looked like neither fruit nor flower. On the opposite wall, on the staircase side, above a big oak table was a map of Sicily, black with age. High on the walls, just under the coffered ceiling, a series of portraits of the kings of Sicily, Hauteville, Hohenstauffen, Angevin, Aragonese, Spanish, Savoy and Bourbon, followed each other in stiff detachment. The colour scheme of the whole ceiling, walls, furniture, decorations, ran from pale to dark umber and every kind of chocolate and *café au lait*. Every available space, except for the parts of the furniture on which you could sit, was crawling with coronets, coats of arms, initials and mottoes. A few rusty pieces of armour, halberds and swords hung on the walls and some even dustier old flags hung from the ceiling. Needless to say, there were also the inevitable potted palms.

The next room on the right was the centre of our life: we always gathered there before and after meals, as the dining-room was on the other side of the hall. Completely covered with *trompe-l'œil* frescoes of banisters, urns and statues, it was known as *La Stanza del Telephone* because it boasted this contraption stuck on the wall under the feet of a contortionist *putto*. Underneath it, two movable wooden steps enabled us children to reach the mouth-

piece when Father or some cousin wanted to speak to us. In the middle of the room, a round table covered with a yellow, heavily-fringed damask cloth supported various magazines such as *L'illustration*, *The Illustrated London News*, *Le Revue des deux Mondes* (Grandmamá's) and *La Revue de Paris* (Mamá's). These publications formed a neat circle around a huge potted fern. There was also a bridge table, seldom used, varied chairs, armchairs and banquettes, *guéridons*, work-baskets and a big table next to the window on which a jigsaw was always laid out. In spite of all this furniture, the room was not cluttered, as all the rooms of the villa were large with very high ceilings.

The next room was the *salone*, also frescoed from top to bottom by some indifferent artist whose name has mercifully been forgotten. On two of the walls, the four seasons (my favourite being a winter that looked like Santa Claus) alternated with mirrors encrusted in landscapes. A great composition on the third side dominated the whole room. It pictured a ridiculous young ballet dancer, dressed *à la Romaine*, sitting on a kind of throne under a tent; he was bestowing a coat of arms on another ballet dancer in flimsy armour who knelt in front of him with his shield held out. The seated individual was supposed to represent, of all people, Charlemagne. The ceiling showed the Virgin Mary ascending into Heaven amidst a host of angels in the most improbable positions. The terrace, which had a twin on the other side of the façade, used to be covered with a striped awning in spring and summer when the families' activities were transported there from the *Stanza del Telefone*.

But to continue our tour, we pass now, leaving Charlemagne to his *pas de deux*, into the green drawing-room, *La Stanza Verde*. How it came by that name is a mystery. There were, it is true, six very pretty regency tapestries that might or might not have had a few greenish leaves in their trellises, but the rest of the walls were red, and red velvet at that. It was a ballroom and contained no furniture except for some settees along the walls and an upright piano. I had to cross this alarmingly empty space several

times a day to reach our quarters. It was always dark. Someone had told me that a bear lived behind the piano which was waiting to catch me. If alone, I would run through this dangerous zone at top speed with my heart in my mouth, but it was even worse when there were people in the next room because I was ashamed of my cowardice and didn't want them to hear me gallop and bang the door as I reached the other end. What a heavenly age, when one's only fear is a non-existent bear!

Thus panting, I would catapult myself into the next room, which was small and known as *La Stanza di Tobia* because the ceiling was painted to show Tobias's son walking along a river with his fish, his dog and his angel.

It was in this room on a windy night in March – to be precise, on the twentieth at twenty minutes before midnight – that I was born. Which, incidentally, from an astrological point of view, makes me a very rare specimen indeed, that date being the last day of the astrological year, the last day of Pisces and the last day of winter. My mother usually slept in a room nearby but had been transferred to *La Stanza di Tobia* on the occasion of my advent. To this day my young cousins, who own the villa now, show this landmark of dubious merit to totally disinterested visitors as 'The room where Fulco was born'.

On the other side of the entrance hall was the dining-room which gave on to the second terrace. It was preceded by yet another sitting-room, where nobody, to my knowledge, had ever sat, and was followed by my grandfather's bedroom. This was locked and steeped in mystery. I never saw the inside of it and only much later realized that Grandpapa had died insane. Hence the mystery and the silence.

The rest of this great house rambled along, room after room, corridor after corridor, upstairs and downstairs, servants' rooms, servants' dining-room, a place where the bed and table linen was washed, a long back terrace where it hung to dry and a room where the table-cloths were waxed and starched and, of course, a cavernous kitchen on the ground floor.

7

The villa had the shape of a perfect square, the two sides of which I have tried to describe. The other two sides housed the stables and the saddle-room, the coach-house and several horse-boxes. In the middle was a vast courtyard with a tall, scrawny palm tree. This courtyard was another world and lived a very intense life of its own, always full of movement and noise: coachmen and grooms gesticulating and yelling at each other, horses pawing and neighing, the barking of a dog, the cooing of doves, the furtive rustlings of hens who were not allowed to emerge into the open but were nevertheless sometimes heard, all formed a rustic symphony that, especially in summer time, was the background music of my daily life.

In two private boxes next to each other were two ferocious animals, heard but not seen. One was a dwarf reddish mule and the other a huge ram. Every time someone passed nearby, the former would kick furiously against his door, and the latter would instantly butt just as vigorously against his own.

These two wild creatures belonged to me. In principle only, because actually I was not allowed to go near them, nor had I any inclination to do so. The mule, *il muletto* as it came to be called, had been given me by my grandfather, together with a little dog cart, for my third birthday, but it had proved untrustworthy even with grown-up people, let alone a poor innocent infant, and had had to be put under lock and key. There was, however, one individual whom this fiend seemed to love, or at least tolerate – old fat Antonino, the head coachman, who ruled over the stables and the courtyard. *Gnu* Antonino would take him out for a run every morning and it was indeed a strange sight to see this very fat old man overflowing from a child's dog cart pulled by a midget mule.

Before I proceed, I must explain that in Sicilian parlance the top coachman had the title *Gnuri – Gnu* for short – from *Signuri*, alias mister, just as all chefs were called and addressed as *Monzu*, from *Monsieur*, as in theory they were supposed to be French or at least to have been to France for a period of time to be instructed into the mysteries of *La Cuisine Française*. As a matter of fact, our *Monzu*

had spent some time in London and could produce steak and kidney pie, Yorkshire pudding and other English specialities and very good they were, even though in their voyage from the shores of Albion to the bays of Sicily they had gone through a verbal transformation. Thus mince pie had become *mezzosposo* (half bridegroom) and strawberry fool had been transformed into *strabbifuoddi*!

The big and smelly ram, who lived next door to the mule, had once been a sweet little lamb and had been given to me by some nuns as an Easter present. I think that its enforced celibacy accounted for its foul temper.

Another denizen of this square world around the palm tree was a nanny goat, of no particular interest except for its astonishing voracity. (An unfortunate compulsion which proved to be its downfall as it blew up after an orgy of empty tin cans.) This insignificant pet also belonged to me.

My sister had a charming, vivacious pony called Nini – but pronounced Nninni, with a double N in front of each I. Why, I could not say. Sometimes as a great favour Maria Felice, my sister, would take me for a drive in her *tonneau* and we would go to call on neighbours. You see, she was the eldest and Grandmama's favourite and the best things were for her, so that instead of a pony and a *tonneau* of my own, I just had a donkey and a Sicilian cart. The animal had no character or personality, not even a name but just *sceccareddu*, the little donkey. The cart was beautiful to look at with the story of Rinaldo and Armida painted on its panels and on the plumed harness. But it was sheer agony to drive as Sicilian carts have no springs, and if the pains I suffered in my back and little behind were supposed to prepare me for the hardness and discomfort of life, they utterly failed because I went on liking my comforts. There were also the horses, six or eight of them. They had grand names. Cassio, that was my favourite, Marcantonio and an imposing chestnut mare known for some hidden reason as La Bognanco. Also, a little bay known as La Baietta.

Last, but by no means least, in this animals' Debrett of the

courtyard was a dowager – a *scecca vecchia*, a venerable, lame, white donkey whom we adored – I don't know how old she might have been, I had known her all my life, wise, kind and infinitely patient. She died peacefully just before we had to leave these beloved grounds to face sterner realities.

Do not, now, think for a moment that the fauna of the villa began and ended in the courtyard. Follow me once more into the garden and I will lead you to two large cages nestled in a small laurel grove. In one lived a .nultitude of ever-increasing guinea pigs, the other was the home of a family of white bantam chickens. This part of the garden was my sister's domain where she reigned supreme. She would often punish me for some imaginary or real misdeed by locking me up in one of the cages and refusing to let me out till I had cleaned it thoroughly. Psychologically she was right, knowing quite well that I was far too proud to scream for help. If some gardener or other individual happened to pass by, I always pretended that I was indulging in this barn-like activity of my own accord.

As the years passed and I grew older, bolder and stronger naturally I began to resent this more and more, till one day instead of entering the cage (I remember it was the guinea pig one) I pinned her against it and spat in her face. The Tzar had fallen and little Kerenski had stepped in (to fare, in fact, much better than the real one). From that day on I was never ordered about again.

In a further, mercifully, secluded part of the garden was another cage. A completely different sort of cage with very strong bars, like a dark and lugubrious-looking cave. In it lived a couple of ferocious and extremely indecent baboons that smelled to high heaven. To counteract this obnoxious odour, Grandmamá had planted daturas, which was rather silly of her as these bushes only smell at night – and who would go promenading in the moonlight next to a cage of baboons?

Why these monsters were kept there at all I am at a loss to say, for they were of no use or ornamental value to anyone. I just took

them for granted having always been, even as a child, a person who asks few questions. Several times in the course of the years, the she-baboon produced an offspring and each time, with the same regularity and preciseness, the tender father would smash its little offspring's brains against the bars of the cage. As in the case of my mule, there was only one old retainer who could walk into the cage undisturbed to clean it and pick up the little dead apes. This old man, by name, Manuele, who looked astonishingly like an ape himself, had a way with animals, even with swans, and he once took a wounded one to bed with him, not, I presume, with the same intent as Leda, but because it had hurt itself. Our unfriendly swans, together with a few inoffensive mandarin ducks, lived a stupid life on the rocky little island in the rocky little lake.

These were the main animal residents of our world, but over the years there were many transients who came and went. There were several monkeys who invariably didn't survive their first winter, dying of pneumonia. Monkeys have never had any real appeal for me as they seem to be, so to speak, too near home, but one I remember kindly. It was a little *ouistiti* with a very long name that I can still spell – Shinshitrscaramanganananusaiamahowa – which we found in some book. Poor little Shin was a timid little soul and suffered from a form of diarrhoea; every time he saw a new face he lost control out of sheer nerves. As the house was like a sea port with people coming and going all the time, and as he was usually perched on a shoulder or on a piece of furniture, the results were disastrous. Other creatures who lived with us were a mongoose, a couple of squirrels that bit me, innumerable tortoises, white mice and a chameleon who promptly changed colour once and for all and died.

Of course, there were also the cats but these belonged to Grandmamá and were considered special to her; they didn't have much contact with anyone else. Picciolino was a lazy, fat black Persian, an Eastern potentate of few miaows, supposedly a tom, though he could never be persuaded to have intercourse with either of his two wives. He was also terrified of mice and would

run for cover at the sight of one! Incidentally, the wives were enormous creatures whose very names I have forgotten.

I have left to the very end of this survey, the dogs – for they were to us not merely animals like the rest, more or less loved, but our loving and beloved companions, friends and sharers of every emotion. How can I begin to describe these creatures who were, after the family, the nearest and dearest things we had?

First, there had been a mythical pomeranian aptly called Lulu, but I only knew about her from a photograph I had seen of an amiable-looking creature at the feet of a little Maria Felice. History really begins with a pug named Musetta (of *Bohème* fame) but I remember little about her. When she died, someone gave us a puppy that was supposed to be a pug. She was named Musetta II. Unfortunately she grew into a very strange animal indeed. Imagine a very fat, sandy-coloured lady on long spindly legs, the crimpish tail of a tired pig and, of all things, a pointed black nose over a protruding lower jaw with little white teeth showing. Yet in spite of her physical drawbacks, she had great poise and a personality of the first magnitude. Intelligent but lazy, lovable yet distant, very philosophically inclined, she was a great lady of the canine world. Like most mongrels, she enjoyed perfect health and lived to a ripe old age, sharing our sorrow when we had to leave the villa after Grandmamá's death and came to live in the dark Casa Verdura in town. When she died, we buried her in the pretty little garden there. During the Second World War a bomb completely pulverized her humble grave so that nothing tangible remains of this beloved, faithful creature who graced with her silent presence most of our childhood. We had composed a little ditty for her in a kind of pidgin Italian and pseudo Latin:

> *Potamus immensus*
> *Bottoni redingottensus*
> *Piccolo portentus*
> *etc . . . etc . . .*

The second line refers to her teats which reminded us of the

buttons on a redingote that a certain baroness wore every season for years.

Her husband (Musetta's, not the baroness's), who was a very good pug with a pedigree, called Dick, was also such only in name, because soon after he arrived he was run down by one of the very first cars seen in Sicily, owned by a ridiculous man called Dr Guccia whom we hated ever after, he and his jolly nieces. (Anyway, he wasn't a doctor at all!) Dick survived, but his hind quarters remained limp. The family carpenter built him a little seat with two wheels attached to his posterior when he wanted to move around. All his life he remained terrified of any noise which suggested a motor; even the honk of a horn would send him crawling under the first object available. At night he slept in a doll's cradle and wouldn't go to sleep unless a certain doll's bonnet was tied under his chin. I can still see his black, mushroom-like face peering from under a green velvet bonnet with pink ribbon frills. My sister always hated and despised dolls, so the dogs inherited all the paraphernalia connected with them, including a doll's house that greatly intrigued them.

Dick's death was the first real and great sorrow of my life. The poor pug had been very ill for some time and, when he eventually died, because of our great love for him, we were not immediately told the truth, but simply that he had become too ill to be disturbed. We were allowed, however, to bring him his food and leave it in front of a little kennel which had been put under the steps of a wooden staircase where it was very dark, but we were warned not to wake him. After a couple of days, as Maria Felice and I were having a heated argument as to whose turn it was to take the food in, one of the maids who happened to be there said to another in a stage whisper, 'How stupid can you be to fight over the dinner of a dog that's been dead and buried for three days?' These words tore for the first time at the gossamer curtain of light that enveloped my young life, a blast of cold wind blew to bring the first moment of desolation, that ghastly feeling of emptiness that gets you in the pit of the stomach. Many more

were to come afterwards of more tragic nature, but none has left a deeper impression on me.

There was also Lady, a Blenheim spaniel of gentle mien and impeccable manners, highly decorative in an early eighteenth-century house. She was the governess's pet and, at the slightest provocation, they would both retire together into Albion's splendid isolation. My sister had a theory that they had long conversations with each other, all about us.

A fatal mishap from a social point of view was another *soi-disant* Blenheim puppy (I wonder where Mother found these freaks? – there must have been some economical side to it). It never stopped growing in length and ended up looking like a fawn-and-white long-haired dachshund with a pekinese head and a trailing bushy tail. This vivacious young lady and legendary flirt responded to the name of O-Kiss-Me-San (Kiki for short). It turned out to be a predestined name because she got into one jam after another with the only too obvious consequences. It was an extremely difficult task to get rid of these little monsters. Some we used to give to credulous country families saying they were the very latest fashion in England, and when they asked the breed, we would breezily answer, 'English'.

2

THE READER will be wondering why I approach the subject of the human beings who inhabited this blessed villa only after a survey of the animal kingdom. Thinking back after more than half a century, the creatures seem to form an integral part of the picture and to be related to the trees and very stones of the house, whereas the humans stand on their own and most of them, except alas my grandmother, went on being part of my life long after we had gone away from the villa.

At the top of the hierarchy, on a throne fashioned out of affection and awe in equal parts, sat Grandmamá, Maria Favara, Princess of Niscemi. She had been a very beautiful woman, according to the taste of the nineteenth century, but what I remember, and with what tenderness, is a rather plump little lady in black with finely-chiselled features under a halo of dazzling snow-white curls, always holding a fan in her hand. She had

married my grandfather, Corrado, Prince of Niscemi, at the age of sixteen. He had been one of Garibaldi's one thousand, was later made senator of the kingdom, and, as far as I know, had had a serene and happy life. It had been a great love match and a happy marriage marred only by one great tragedy. A little boy had been born to them long after the others. He naturally became the very apple of his mother's eye. His name was Enzo and apparently he was a very promising and pretty boy. At the age of twelve, he woke up one morning with a temperature and by noon he was dead. The verdict of the doctors was a pernicious fever. Grandmamá lost her reason for many long months and her faith forever, to the permanent sorrow of my mother who was deeply religious.

As children we were never allowed to mention Enzo's name, his room was under lock and key and was kept just the way it was on the morning he died. His old nurse, Nina Costa, who lived in the village, had the key and came once a week to dust. On my mother's bedside table there was a photograph of a boy in a Norfolk jacket with both hands on the handles and one foot on the pedal of a bicycle, looking very seriously ahead. This half-faded smudge haunted me. That closed door on the second floor awed me so much that I would instinctively lower my speed when passing it. After Grandmamá died, when inquisitive men were making inventories and looking for papers, nothing was sacred any more, so I dared to enter that room, and saw the made-up bed, the desk with the unfinished homework and big musical box, with its copper disks with little holes in them, a few photographs of dogs and horses, a pair of little slippers and in a corner . . . a bicycle.

Grandmother always wore black after that and stopped following the fashion. She wore little black bonnets like Queen Victoria but, thank God, no ribbon tied under the chin. For weddings or christenings she would enliven her austere apparel by tying a little mauve aigrette onto her bonnet and by fixing an artificial bunch of Parma violets (from Lespiaux in Paris) at her waist.

Very cultivated and well read, she was extremely proud of her mastery of languages and spoke fluent French and German (of the latter I can only write by hearsay having, since babyhood, put up a mulish resistance to learning that language). Her English, alas, was a bit erratic. Somehow her aitches had a habit of vanishing or popping up in the wrong place. For example, one never knew which of howl and owl was the bird and which the screech. On their arrival the new governesses had to be advised not to take any notice of this cockney trend as she was certainly not a person to be corrected in any way. Very fond of travelling, for months ahead she would plan her annual ten-to-twelve week tour of Austria, Belgium and Holland or the *châteaux* of the Loire, always ending in Paris in October, so that she could dash back home in time for All Souls' Day, *I Morti*. She also often went to Rome to see her eldest daughter Caterina, Princess of Paterno.

Every Sunday she held a small party for her friends and any visiting foreigner 'of distinction' who happened to be about. In summer these very tame receptions were held in the garden – garden parties being all the fashion then. We were allowed to invite our friends too, which delighted us as we could then show off in front of those despised children who lived in town.

Grandmother was charitable, kind and profoundly understanding of other people's foibles and weaknesses, but set in her own opinions and not to be trifled with. For instance, every time we arrived at the Gare de Lyon, in Paris, she would become exasperated by the jostling and fussing of the French porters and invoke the Prussians to come once more to teach them discipline – at which my mother, horrified at such a prospect, would cross herself.

Constant visitors to the villa were two spinsters who always arrived in a black coupé with a coachman and an urchin dressed up as a groom. From this contraption would emerge the two little women, the Signorine Salandra, one thin and the other plump. The first, Carolina, had a hooked nose and the other, Giulietta, a pointed one. Like two little birds of different species

they were chatty and jolly and had a nickname for everyone. Thus, Grandmamá was La Cara Bella and Mamá, La Cara Simpatica. And that is, after all, the best definition in three words of the person I have loved most and have been most loved by in my life.

Mamá was born Carolina Velguarnera di Niscemi, she was not beautiful but had a very good figure, thin and erect, soft brown eyes, a proud Bourbonic nose and the most beautiful hands, white as ivory and always cold; she also had a profusion of dark hair that soon began to go grey. It seems that I once said to her, 'Mamá, why aren't you as beautiful as Franca Florio?' – who was then the most beautiful woman in all Italy. She would repeat this story which made me blush every time.

Mamá was what would now be called in America a compulsive reader, but was then just someone who liked books (a trait that I have inherited). The little paperbacks of the Tauchnitz Editions poured in and were instantly devoured. One of her favourite authors was Wilkie Collins, not merely *The Moonstone* and *The Woman in White*, but *Armadale, Basil* and all the rest of them. The two French Revues offered her Paul Bourget, Henry Bordeaux and Marcel Prevost. In Italian, Fogazzaro was read with trepidation and reservation on account of religious scruples. D'Annunzio's novels were read in French. (Why spend the money buying them as they come out, when in a year's time they would appear translated in the *Revue de Paris*?) This sounds a bit affected, but she made her point when later he actually did start to write in French. She loved his poems and it was a treat to hear her read *La Passegiata* or *Hortus Larvarum*.

Profoundly religious but no bigot, I often heard her say that she had missed her vocation and should have taken vows. She would have made a very peculiar nun as her wit was particularly sharp and her repartee always ready. She had a gift for demolishing someone or something with a couple of words. She was certainly no prude, and, in spite of her virtuous life, did not flinch from using saucy language, even slipping in the occasional four-letter

word. Much later we kept a little book in which we inscribed her more spicy remarks. It was called: *Dictons Pornografiques d'une Femme d'Eglise*. In other words, her sense of humour was prodigious and, in spite of the worries and problems that besieged her throughout her life, and which she certainly did not keep to herself, her company was always rewarding.

My father and mother were second cousins and both came of old Spanish stock. Our family name was San Esteban y la Cerda which was later italianized into Santostefano della Cerda. The La Cerdas were descended from *infantes* of that name who were grandsons of Alphonso x, the wise king of Castile and Leon. Their father, Don Fernando, had married his cousin Blanche, daughter of St Louis, King of France. When he died, a wicked uncle, whose name I can't remember but which surely must have been either Alphonso or Fernando, became guardian to the two little boys and was declared Regent of the realm. He promptly snatched the throne and sent the little boys packing. Although they never managed to get their throne back, they were for a long time thorns in the side of the Kings of Castile and at one point the Pope made the eldest brother King of the Canaries (such a melodious title), to try to calm him down, but he refused to budge.

By the beginning of the seventeenth century their descendants were living in Sicily as, by then, the Kingdom of Sicily was under Spanish rule. The last of the Sicilian branch of La Cerda was Donna Hippolita, a spinster who married her cousin, Don Diego San Esteban. To commemorate this great event, the title of Marquess of Murata La Cerda was created and a fortified town of that name was founded.

In spite of its mighty-sounding name, the town had long since passed into other hands by the time I visited the place. The once-great feudal estate had been reduced to a miserable-looking village, semi-deserted, squalid, with the remains of a single-storey palace on one side and a church studded with coats of arms on the other. Of the walls not a trace, perhaps they were never built.

19

Incidentally, 'la cerda' in Spanish means 'the sow', or, rather, the female wild boar. The title was first bestowed as a nickname on those two hapless little boys because they were very hairy or, as another chronicler relates, they were afflicted with hairy moles on their shoulders. But in any case to be known as the children of a sow was a bit rich, when you consider that the sow in question was after all the daughter of the canonized King of France! (Whose heart, by the way, is preserved in the Cathedral of Monreale, outside Palermo.)

The Verdura title belongs more or less to the same period, to the first half of the seventeenth century. It came to us through the female line, for my paternal grandmother, Felice, was the heiress to the Benso di Verdura. She married Giuseppe (Beppe) della Cerda; it was, I believe, an unhappy union but I never knew her as she died before I was born. Beppe lived in Nice with his second wife who was the widow of Eugene Isabey, a fashionable painter of the Second Empire. Eugene's father, Jean Baptiste Isabey, had been well known as a miniaturist at the Court of Napoleon, and his son's widow possessed a fine collection of little portraits of high-waisted ladies.

Now my dear Mamá coveted these little portraits for me. One year, whilst we were in Nice, I was briefed to admire them and was taken to see them every day. I hated these visits. I had no feelings for this rather fierce-looking grandfather of mine with his large nose and gruff voice. I had never seen him before and, for that matter, was never to see him again. His wife, whom he called affectionately Emma Mignon, looked like a teacosy in the shape of a fat hen. It was most embarrassing for me to hear Mother say, in mellifluous tones: '*Mon cher petit aime toutes les belles choses, surtout la peinture, maintenant il ne fait que parler de ces petites merveilles.*' (She could not then know that in the distant future I would start painting little pictures myself!) At that point in time however, *les petites merveilles* bored me to distraction and all I wanted to do was to get out of that stuffy apartment and go into the garden in the Place Massena. Alas, these little indignities

were utterly in vain, because when this worthy step-grandmother of mine died she, quite naturally, left the portraits to the Isabey and Morisot families. She had been born a Morisot and was, I think, related to the Impressionist painter, Berthe.

In the Kingdom of Sicily there existed La Camera dei Pari, the rough equivalent of the English House of Lords. Every peer of the realm had a number which was given to him according to the date, size and importance of his title. It was therefore possible for some marquesses, counts and barons to have higher numbers than dukes or princes. No doubt this sounds totally incomprehensible to British ears, but so it was. Cerda was more important and had a much higher number, for instance, than Verdura.

The heir to all this heraldic paraphenalia was, after his brother, Alessino, had died of fashionable consumption at the age of twenty-seven, my father, Giulio Sanstefano della Cerda. He and Mamá had been childhood friends, but had not seen each other for years until he returned to Sicily as an officer in the crack cavalry regiment, the White Lancers of Novara. This regiment had been stationed in Brescia and all Italy had been talking about the officers' extravagance and the trail of debts they left behind when they were transferred. The morning after their departure, the walls of Brescia were covered with a notice saying: *I duchi e i marchesi sono partiti ma i conti sono rimasti*. The dukes and the marquesses have left but the counts (bills) have remained. So, surrounded by an aura of glamour, my father arrived in Palermo.

They fell in love with each other, married and were utterly unhappy ever after. Many years later Mother used to recall how, on the first night of her honeymoon as she lay in bed waiting, she saw coming into the room a very stern, dark young man in a long night shirt with skinny legs and red slippers instead of the elegant cavalry officer she had fallen in love with. Then and there she realized that she was not made for love. So after a few years together, he remained at the Casa Verdura in Palermo and she went to live at the Villa Niscemi with her mother, taking with her my sister aged two.

21

Then the most extraordinary situation occurred: a husband and wife who lived apart, who were practically not on speaking terms, who disapproved of each other, who were separated *de facto*, if not *de jure*, decided to continue to meet and to go to bed together in order to produce an heir. First came a poor little boy who died right away: my father always referred to him as Garibaldi, saying that as he was dying and had to be baptized instantly he could think of no other name. (Surely an apocryphal incident only invented to irritate Mamá, which it duly did.) And then in the course of time, at long last, I made my appearance.

After this momentous event she rarely, if ever, returned to the house in Palermo, to the nuptial bed, a pseudo Louis xvi monument which she referred to as 'the place of crime'. For the sake of appearances, and because of us, they remained on polite terms and he came to lunch at the villa every Sunday. This suited us perfectly for it meant that we were loved by both sides and ended by being utterly spoiled.

It always amazed me that my father and mother were in fact second cousins, for Father appeared to belong to another breed, another race altogether. Extrovert, quick-tempered, at times violent, opinionated to a degree, he was supposed to possess great charm, knew it, and turned it on like a tap. I have to admit that this charm seldom worked on me, but then it was generally oozed out for the public's consumption and not for the family's. He loved the ladies and was a perfect gentleman, always ready to take up arms in one cause or another. His greatest asset to us was his love of animals, not only horses but all animals. If he saw a coachman or a cart driver thrashing his horse or donkey, he would pounce on the wretched man and beat him up. Father, surrounded by his horses and dogs, dispensing justice in the streets of Palermo, is an image still remembered by some old people. A very good horseman, crack shot and clubman, he had courage and a great deal of panache. All the same he was a bit awed by Grandmamá, who, on her side, disapproved of practically everything he stood for.

To complete the portrait, I should add that he was tall, thin, dark and dashingly handsome. He took great care of his sleek, raven-black hair and his nails were always well manicured. He fancied himself to be, and probably was, a great lady-killer. He was proud, sure of himself, had fought several duels and was often consulted on questions of honour. In fact, a typical gentleman of the period.

Now let me tell you about my darling sister, Maria Felice. She was older than I, but, as the years passed, the gap between our ages seemed to become smaller and smaller and we understood and loved each other more each year. An oval face, large black eyes and swarthy complexion that showed the colouring underneath when she blushed (quite seldom) or got angry (more often). Her face lit up when she smiled but, when something was wrong, you could actually see the dark clouds gathering on her brow. Only really happy when out of doors, she was fearless but also full of compassion. The sight of an animal being ill-treated would turn her into a tigress, sending her flying to the rescue of the animal and the annihilation of the culprit. Her favourite companion was her cousin, Maria Giulia, a mischievous, intrepid amazon of about the same age. When they were together, they formed a formidable team who knew few obstacles that could not be overcome.

Borrowing my Sicilian cart and poor little Sceccareddu, they would set out dressed as peasant girls (*Cavalleria Rusticana* style) in search of mischief. They had found an old camera, totally disembowelled, but on its tripod. Armed with this and a piece of black cloth, they went about taking family groups of unsuspecting retainers, who had previously been advised to don their Sunday best. After a week or so, the victims were told that something had gone wrong and that the operation must be repeated. Every time the poses became more complicated and the sittings longer and longer.

'Please smile.'

'Don't squint.'

'Angelina, don't sit on that chair as if it were a pot.'

'Blow that child's nose.' Eventually they would tire of the game and start another one.

Unfortunately Maria Giulia was not always on hand; she belonged to the 'Roman' cousins, as we called them, though they were no more Roman than we were but just happened to live in that city at the time. However, as I grew older I was always on hand and was eventually allowed to become part of their team as a sort of page. They even let me explore the roof with them and discover its denizens of rats, bats, lizards and geckos.

Maria Felice always had a passion for horses and dogs. I don't think I've ever seen a snapshot of her without some quadruped. When Father's horses were being trained in La Favorita, there were violent scenes if she wasn't allowed to go and watch. Quite in keeping with this inclination, she eventually fell in love with and married the finest Italian horseman of his day, my dear brother-in-law, Tom Lequio di Assaba.

Our love of animals sometimes went too far. When we went, most reluctantly, to live in Town, we found that the Casa Verdura, which had not been used for many years, was infested with mice. Every evening traps were set in the hall and in all the rooms. Maria Felice was 'out' by then and so used to come back from her parties very late at night; she would return to find a note scribbled by me on the top step of the stairs: '*Libera i topi*' – Free the mice. This duty she would conscientiously perform, making the rounds of the great house in her ball dress, until she was quite sure that no prisoners were left.

If Maria Giulia was not only her favourite cousin but also some-one my sister greatly admired and sometimes imitated, there was another cousin who inspired very different sentiments. This one was older than us. For some unknown reason she attracted upon herself one calamity after another. If there was some devilry stewing, she was inevitably the butt of it – not that we disliked her or had anything against her, on the contrary we were quite fond of her, but it was an established fact that she had been created to be

teased and mentally tortured. To begin with, she was at school at the Sacré Coeur Convent in the Piazza Olivuzza in Palermo, a grim-looking building half prison and half barracks. Every time we went to see our dear red-headed friend, Anna Camporeale, who lived on the same piazza, we gloated wickedly on the fact that while we were playing in Anna's garden, she was behind bars, only a few steps away.

In this French establishment, girls of good family were taught good manners and bad French, also prejudices and how to bath, I don't know how often, with their nightgowns on. We knew other pupils at the Sacré Coeur, the two blonde Oddo girls, for instance, Giovanna and Maria, who were also relations of ours on Father's side, but we didn't feel the same prurient desire to torment them. We only pitied them because they were locked up. But the fact that this cousin was an inmate of a nunnery was a source of derision. I will not say her name as what I am about to write is anything but kind. She was short and on the plump side. With her round face, little beady eyes and long, straight hair that she wore in plaits, she could have easily belonged to the Eskimo race. When she stayed at the villa, she naturally came to the beach with us to bathe. Coming out of the water in her black woollen bathing suit, with her long lank hair streaming down her back, we decided that she smelled rather like a wet dog. Using this aroma as a base, we invented a phantom dog, which we talked about loudly: 'Did you notice how Fido smelled worse than ever today?' or 'Really Fido should be washed more often.' She, poor girl, couldn't understand why she never saw it, nor why we kept talking about an animal that wasn't there. Said we, 'Don't be ridiculous, he was here just a minute ago, didn't you hear him bark and anyway, use your nose . . . his smell is still in the air.' The years passed and we, alas, all grew up, but for her the mystery of the dog Fido remained forever unsolved.

Being brought up in a convent she was, naturally, very bashful and ashamed to show even the smallest particle of her flaccid pale anatomy. This made that wild sister of mine concoct a devilish

plan, that nearly succeeded perfectly. As I have said, our garden had a little lake with a tiny island in it. The water was so shallow that it just came up to my knees. It was very slippery and dirty, but we often paddled in it. One day Maria Felice cajoled her cousin to do the same. So having taken off her black shoes and stockings, she got in and before even attempting to put one foot in front of the other, she fell into the slime, her skirt billowing around her. She was helped out and made to take off her uniform to let it dry in the sun. At this point I was sent away for modesty's sake, but I took cover behind some bushes to enjoy the scene. Maria Felice persuaded the unhappy girl to try once more and half supported and half dragged her to the island. When they had thrown all their bread to the ducks and swans, Maria Felice waded right back on the pretext of getting some more and calmly went home humming a tune, leaving the forlorn creature stranded on the island in her undies.

Ashamed to be found unclad and afraid of venturing into a lake infested by hissing swans that she had perfidiously been told were very vicious, she just stayed where she was, like Ariadne at Naxos, until she became desperate. In the meantime it was getting dark. The governess began to wonder what had happened to her and, knowing quite well that our cousin was not the kind of girl to go venturing by herself out of doors in the twilight, she began to suspect that some dark deed had been perpetrated and started to cross-examine Maria Felice, who denied any knowledge of the missing girl's whereabouts, saying only that she had last been seen wandering in the furthest part of the garden. The alarm was given and a posse composed of the governess, Miss Aileen, a footman and one of the maids set out to search the grounds, much to our hidden amusement. She was eventually found, through the discovery of her wet uniform, shivering, speechless with shame and terror, and taken to the house wrapped in a blanket just in time to hide the whole episode from Grandmamá before she returned from Palermo. She would not have been amused.

Once Maria Felice went a bit too far and the incident I am about

to relate could have had serious consequences. It was a hot summer day, the courtyard was quite empty and silent. In the middle of it the tall, scraggy palm tree, motionless in the still, hazy air, might have been made of zinc. In front of it stood our hapless cousin in her drab Sacré Coeur uniform, her flat, found face turned up towards the balcony where we were with a couple of dogs. For what reason she had not come upstairs with us, I do not know, let us say that fate had kept her down there. Anyhow, there were the three of us, the two girls chatting away and myself, as usual, doing nothing. What they were talking about, I don't recall, but it must have been a matter of little interest to me, as I soon got bored trying to listen to them and my eyes began to wander lazily over the familiar, vacant scene.

All of a sudden I noticed, to my dismay, that the lower part of the door of the loose-box that housed the ram was opening, then its head emerged and it slowly advanced. At this point I nudged my sister to tell her, but, with a forceful kick on one of my shins, she conveyed to me that she had already seen and that I should shut up. The big brute downstairs was now making its way towards the victim, while my sister kept up the chit-chat with chilling sang-froid. When the ram was but a few yards behind her, already lowering its head, Maria Felice said, 'Turn round, I think you have a visitor.' She did! and with the velocity that only fright can produce and that one least expected from a convent-bred girl, our cousin darted around the palm tree yelling bloody murder, pursued by the snorting beast.

At the noise the whole place came alive. Coachmen and stable-boys appeared to join the fray. Her piercing screams aroused the denizens of the courtyard, doors opened, dogs barked, horses neighed, pigeons flew around, astonished coachmen appeared . . . and the chase was on, ram chasing cousin, coachman and stable hands armed with brooms and pitchforks chasing ram, with a couple of dogs joining in the fun. Round and round the palm tree they careered in a fantastic carousel raising clouds of dust. The din was memorable, because not only were the men shouting and the

dogs barking, but because from windows and balconies heads of maids and menservants had appeared commenting in high-pitched voices on the spell-binding spectacle.

At last the wild beast was pushed back into its own loose-box, where it went on discharging its wrath by butting furiously against its door. The victim went into a first-class fit of hysterics and was carried indoors by fluttering maids to be treated to cold compresses and salts. The consequence of this caper was that, after a battle royal between our mothers, there was a rift and we didn't see each other for some time. But after a while, as she was fundamentally good-natured and also preferred to remain on good terms, our cousin forgot, forgave and came back ready for new tortures. The French have a wonderful expression for such people – *souffre-douleurs*. That was precisely what she was to us and to the cousins in Rome. I am afraid we went on being beastly to her for many more years. Once at a dinner in a trattoria by the sea in a little bay called Sferracavallo, she had, before we sat down, taken off one of her shoes. Of course I hid it. We had a delicious fish soup and she was very greedy. As it was handed round a second time, I had arranged that she should be served the last and had bribed the waiter to drop the shoe in the soup. . . .

Beastly to cousins we may sometimes have been and of course we had our sulks and fights like all children, but I cannot think of any other brother and sister amongst our friends who were so close to each other as Maria Felice and I were, and still are today, through our not-always-easy lives.

3

HAVING NOW DESCRIBED the setting and the most important dramatis personae, including the four-legged ones, I want to describe someone from a northern island who had a great influence on my childhood.

I remember little of my life before my fifth year but have been told that my upbringing started under the aegis of a German nurse, one Matilda, of whom I remember nothing. Later I learned that she had had a tempestuous affair with one of the coachmen called Isidoro, of all names, and so had to be asked to return to her primeval forests. Actually the main reason that had forced Mamá to this decision was the time she had looked out of the window and had seen this passionate virago pinching my arms and boxing my ears.

That put an end to the Hun influence in our household. Instead, the door was flung open and Britannia marched in.

The first representative of the might of the British Empire was Miss Aileen Brennan, our first governess, or rather nursery governess, a title that implies, I presume, smaller fees. She was sedate, quite pretty and obviously Irish (on account of the religion you know). She stayed with us for five years and, in the many snapshots or 'groups' taken at that time, I'm always near her, often holding her hand. My sister was also fond of her but found her a bit tame for her own taste. Miss Aileen's sister, Miss Alice, was governess to friends of ours and the two sisters saw each other constantly. How strange it must have been for those two Irish girls to find themselves so far away from their own damp green island, stranded instead on our red-hot, parched one. Miss Aileen taught me *The Rose of Tralee* and other Irish ballads. *Londonderry Air* invariably made me burst into tears. I loved her very much, in spite of the innumerable meals I consumed sitting next to her and during which she tried to spoil my vigorous appetite by alluding to my table manners and murmuring in a stage whisper, 'Disgusting, perfectly disgusting . . .' This upset me so that I am, to this day, as she used to put it, 'Not a dainty feeder'.

It was she who brought into my life *The Tailor of Gloucester, Alice* and the *Wallypug of Why*, just to name a few of my favourites. But there were many more: the fat hippopotamus who sat by the Nile and whose features were set in a permanent smile, and the Dodo. She taught me to sing little ditties, especially one that I used to repeat with great glee as I thought it was rather *risqué*:

> Mary had jam
> Mary had jelly
> Mary went to bed
> With a pain in her . . .
> Now don't be mistaken
> And don't be misled
> Mary went to bed
> With a pain in her head.

Miss Aileen's successor belonged to a completely different

species. She responded to the highly-romantic name of Irene de Villiers and hailed from Cape Town. How Mother found her and how she found her way from Table Mountain to our Monte Pellegrino I know not. She couldn't hear a bar of music without picking up her ankle-length skirts daintily with both hands, assuming the dancing first position with her feet and starting to hum one-two-three, one-two-three. In her room she kept, in a silver frame, a photograph of a lady with feathers stuck into her hair dressed in full court presentation regalia. She told us that it was her mother and she was fond of describing the great royal occasion to us. Strangely enough, after she had left, we found that she had taken this picture out of its frame and had torn it into small pieces. This in itself was odd, but, stranger still, when my sister and I laboriously put all the pieces together again, we discovered that on the back of the photograph was a group portrait of a football team with an arrow pointing to one of the players . . . curiouser and curiouser. . . .

After Miss Irene, a pale, ash-blonde, gentle young lady made her discreet appearance. She was called Miss Lilley and was no match for us, as we had by that time grown up a bit. If she ever dared to reprimand us, or to hold English upbringing up to us as an example, we would simply say to her, 'How dare you! Remember Joan of Arc and Napoleon.' She didn't stay very long, I'm afraid.

Another figure who, in spite of her tiny size, loomed over my young years was my mother's maid, Sandrina. A native of Pescia in Tuscany, she was a little plump, partridge-like woman given to contrasting moods and more and more to sulks as the years passed. She remained with my mother till her death during the Second World War. She was very important to us because, during our travels, the governess of the moment would go home, and she would take over the task of looking after us, to our joy.

There were also Grandmamá's maids, or, rather, a roster of them; first and second. The second maids changed from time to time, but they were all cousins and all called Angeline or

Giovannina. On the male side were Angelo, the butler, complete with grey whiskers and pompous parlance, Pasquale, who looked like an elderly spider monkey, Mommino who could always fix something I had broken, and other footmen who came and went leaving no trace in our youthful lives.

As I have said, down in the garden, next to each gate, was a lodge. Two of them were occupied by the brothers Mineo and their vast families who provided the Angelinas, Giovanninas and Rosalias who helped in the house. The third was the abode of the chief gardener and factotum, Salvatore Pipitone, whose daughter Maria, was our constant companion in all our games and had, and has, the sweetest disposition of any human being I have known. There was also a handsome coachman, Isidoro, the one who raised havoc in the heart of the detested German nurse and also, it was rumoured, in Sandrina's.

In spite of nursery governesses, teas and futile attempts at porridge, soon to be given up, it would be an error to think that I was brought up in the British manner. To begin with there wasn't a nursery, in the proper sense of the word. We used as such a big room just outside Mother's quarters. It had two French windows with balconies facing each other, one looking on the garden and the other on the courtyard, seat of our delights. Along the walls were tall cupboards that contained linen, blankets, shawls and also dresses, coats and furs belonging to Mother. One of them housed my clothes and shoes, another my toys, which were supposed to be put back in as soon as I had done with them in case Grandmamá happened to come through that part of the house. This rule, however, was not strictly observed as she rarely made an appearance and also because, with the connivance of the maids, we knew about her movements in advance and so there was always plenty of time in which to hide offensive playthings.

Breakfast was in the dining-room at the other end of the house. I had to cross seven very large rooms to get to it and find my milk 'luke', with that disgusting 'skin' on top of it, which, I suppose, accounts for my everlasting dislike of that vivifying liquid.

Luncheons and dinners were with the grown-ups: the latter never before nine o'clock in the evening. This state of affairs was, not unnaturally, frowned upon by Miss Brennan. Nor could she comprehend why, in a house as big as the Villa Niscemi, I had to sleep in the same room as my mother or why I was always given, as far back as I can remember, a glass of red wine 'lengthened' with water, with all my meals. My sister, as I have already said, being older and Grandmamá's pride, had a very different privileged status: a pretty room of her own and a so-called 'studio' where she was supposed to learn something of the arts, science and graces of a well-brought-up young lady. This 'studio' had been modernized in a feeble attempt to conquer the curlicues of Art Nouveau and was at the very end of the long hall on the second floor next to the cavernous solitary bathroom that was used by us and the governesses (Grandmamá had her own sacred one that no one would have dared to look into, let alone use); therefore we had to cover at least a mile a day coming and going from our rooms to the seats of nourishment, learning and cleanliness. This we found perfectly natural. The governess was more fortunate, as her room was also on the second floor corridor with the other three guest-rooms. One of these I was at last able to occupy by myself when I reached the age of seven. It was known as the White Room and had the advantage of being only four doors removed from the bathroom.

As we are on the subject of sanitary installation, let me relate a little episode that Mamá fondly remembered. When our third and last governess arrived, Miss Lilley by name, she was asked if she had everything she needed in her room. She demurely replied, 'Oh yes, thank you very much, but I was just wondering what that guitar-shaped vase behind the screen was for.' Blushing, my mother had to say that it was called a bidet and explain its intimate use.

Mamá was under the very efficient, if benevolent, domination of her mother who supervised every detail of our everyday lives and education. She concentrated especially on Maria Felice (she soon gave up trying to make anything out of me) and music, literature,

THE HAPPY SUMMER DAYS

Latin and even Greek, were forced upon my recalcitrant sister with no visible result. Then a fascinating creature, whose very name spelled to us panache and romance, was engaged to introduce Maria Felice to Shakespeare and Milton: she was called Miss Harriet Simpson Kay. The buoyant, rippling sounds of these four words still give me pleasure as I write them. Miss Harriet Simpson Kay! With her hats full of ribbons and wings that seemed to have just alighted on her pompadour but might fly away again at any moment! She gave me a first edition of *The Book of Nonsense* that I still possess and you should see her dedication and signature, a cavalcade of bold windswept letters ending in encircling, majestic swirls.

Now Miss Kay had, in our eyes, one fault: she didn't understand the charm of our dear pug Musetta and once was heard to say, 'That animal offends my sense of beauty.' A remark that was not easily forgotten.

At half-past four sharp Miss Kay had her tea. This exasperated her indocile pupil, because it only prolonged the lesson hours. So one day she had a brilliant idea. Our Musetta having just had a litter of puppies (father unknown), Maria Felice conceived the fiendish plan of milking the poor animal and giving the result to her teacher. I was made to hold poor Musetta while Maria Felice tried to milk her. Now if you have never tried to milk a bitch, I can tell you that it is not easy and, I presume, if performed by amateurish hands, extremely painful for the victim. Anyhow, Musetta hated every moment of it and for the only time in her life revolted and bit me (I was always the one who got the worst deal). The meagre result gathered by this unusual dairymaid was put in a jug and poured into Miss Kay's cup of tea and, as she was draining the last drop, we triumphantly announced, 'Do you realize that you have been drinking Musetta's milk?'

The effect of this startling announcement was instantaneous. Holding both hands to her mouth she jumped up and bolted out of the room. After a while she emerged, pale, shaken, yet relieved. To do her justice she proved to be a very good sport and did not

report us. Maybe the thought of Miss Aileen gloating silently over the incident was too much for her? To finish this story, I must add that her dislike for that poor dog was greatly intensified after the tea party, and she would not have her in the same room.

Poor Miss Harriet Simpson Kay. She obviously had a rather blurred sentimental life. She would allude to mysterious journeys with Lord X or to the time when she twisted her ankle skating with a young French Vicomte – 'Of course you know it would be indiscreet to mention their names'. Some other day the magical name of Rothschild would be evoked. 'But which Rothschild, Miss Kay?' we would enquire. 'A Viennese one!' she would reply grandly. Finally, she took to tutoring a girl friend of ours, daughter of a well-known Lothario with whom she got involved, and so she had to leave Palermo. Many years later we heard that she had gone completely dotty and had ended up in an institution.

My first teacher was a certain Signorina Gemelli (or Miss Twins), certainly a peculiar name for a gaunt, elderly spinster with a grey hair mole over her unkissed lips. She used to arrive, having first been to our neighbours, the Gebbierossas, in a strange contraption that looked like a small black maria led by a mule. As I was usually playing in the garden I would see her arrival and instantly go as far as I could in the other direction, hoping to retard the fatal moment of being summoned upstairs. She was the one who implanted in me the first rudiments of knowledge. I was, I'm afraid, by no means an easy pupil. For instance, I invented the habit of acting the lesson of the day to the bewilderment of poor Miss Twins. If the subject was birds, mammals or reptiles, I would flap my arms, walk on all fours making animal noises, or crawl and wriggle on the floor. One of these imitations remains in my mind because it was so realistic that it later became a standard game. She was trying to explain Attila's hordes to me. The book she was reading from stated that 'The Huns were a nomadic people of small stature, who came out of Asia and swarmed all over Europe'. This barbaric, grandiose vision was far too exciting not to be put into action immediately. So up I jumped on the table

yelling, 'I am a Hun of small stature', and then I cavorted around the room leaping on the furniture to the terror of the poor Signorina who had a lisp and could only say, 'Fusco, Fusco, please'. Intoxicated by my own power, I escaped from the room and shouting and snorting, repeating the same refrain, I careered all over the house leaving behind a trail of dismay. Finally I was tracked down to the table in the servants' hall from which vantage point I was intent on scaring one of the maids out of her wits.

There was also Signorina Sulli and her dancing classes. Each of the parents took it in turn to have her come to their house, where we were taught not only the waltz, the two-step, the mazurka and the polka, but something called 'the season' and the Washington Post, and every lesson ended with Sir Roger de Coverley. I simply adored these lessons and eventually became a very good dancer. My favourite partner was a little English girl called Boots Whitaker – but you will hear more about her later.

4

BUT WHAT OF MYSELF? Well, I was a sturdy little boy, well planted on my short legs, seemingly in perpetual motion, running ('May I skip?'), jumping on furniture, climbing up trees or trying to stand on my head, then suddenly stopping in my tracks to lose myself in some faraway daydream. At home I usually wore blue serge short trousers and a blue turtle-necked sweater, black button boots and black socks that seemed always to be falling down. This indoor attire was referred to as *il vestito di casa*. For outings, the attire was strictly nautical: sailor suits. A blue serge one in winter from Peter Robinson: in summer a linen one with a tiny blue-and-white stripe from Peter Jones. In fact, the pants of *il vestito di casa* were simply the nautical winter ones of the year before. These two seasonable Peters from distant Britain had become in my imagination two mythical beings that never could be together. Did Jones hibernate in winter? Did Robinson melt under the summer sun?

My headgear in season was a large straw hat held in place by an elastic that had become much too long from perpetual chewing, so was always having to be shortened by knots under the chin.

Such was I. Or, rather, that is how I remember having been, in those distant, happy, sunny years. Always able to use a pencil, I drew maps of imaginary countries, usually islands, with their mountains, rivers, bays and towns. Then I would draw views of the capital with its churches and palaces, and of course the royal palace – these islands were, as a matter of course, always kingdoms as I didn't know what other kinds of government might exist. I invented strange names, now forgotten, and called the kings and queens after our animals – Dick, Musetta and so on. But I do remember calling one of those countries by the name of Table and, in it, lived Le Baron d'Agneau with Châteaubriant, the Demoiselle de Caen and Sir Loin.

Several times a day I had to pass a bookcase full of large, imposing books in the hall. The only ones I could reach were the lower ones which happened to be the Larousse dictionaries and these became my everlasting mine of knowledge. The first art book I investigated was a heavy volume bound in dark green leather; on the front, reproduced in gold leaf, was a medal bearing the profile of a young man with long curls and a tam-o'-shanter: Raphael-Sanctius-Urbinas. It was the Raphael by Eugène Müntz. I can see myself now carrying the precious tome into the White Room, sitting on the bed and slowly turning the pages where the pictures were to see those noble, serene faces looking back at me. My first uncertain steps in that miraculous garden that is the Italian Renaissance. There and then began my love affair with Art, in all its different forms, and my hunger for knowledge. This hunger is still within me. Old as I am, I still get a lump in my throat at the sight of the *Annunziata* of Antonello de Messina in Palermo, the *Resurrection* of Borgo San Sepolcro or Raphael's *Sybils* in Santa Maria della Pace in Rome. This opening of the eyes added new dimensions to my joy of travelling. I can remember *The Tribuna* of the Uffizi and the *Salon Carré* of the Louvre as they

were then. Two *Sancta Sanctorum* that reunited works which were then thought to be the pick of the lot. I wonder if such a selection were to be made now which would be the chosen masterpieces? I am sure not the same. To me, only the Pitti Palace preserves that atmosphere of a collection of pictures bought for themselves and not a collection of stamps catalogued in terms of countries and years.

Even in those early days, I was prejudiced and preferred anything Italian above the rest. It is, I am afraid, a trait that still distinguishes me, in spite of having lived about three-quarters of my life abroad in America, France and England. I can think in English and French and both these countries have greatly influenced me, but by the time I got to the US I was over thirty and there was very little virgin soil left to be colonized. It did teach me one thing though – to work!

Another love that started to grow in me was music, but in a different way. The visual arts provoked in me the desire to emulate and, pencil in hand, I started to doodle on every piece of paper available. Music lulled me into daydreams or, if lively, made me want to dance. My emulating stimulus did not get very far but to my great astonishment, I found that I could soon pick up simple tunes by ear and play them on the piano with one hand. This made me very proud but, since there wasn't the slightest chance of my being taught music as it was not considered suitable for boys, I had to content myself with a rendition of *The Pink Lady*, the *Chocolate Soldier* or very ambitiously, *Clare de Lune*. Then came the fateful day when I was taken to a matinée of *Aida* and completely and literally lost my seven-year-old head. This fateful matinée not only opened my eyes and ears to the magic of opera, but it also took me inside a great opera house.

The opera house in Palermo was, and still is, one of the biggest in Europe; the monumental proportions of it had always impressed and intrigued me. The grand entrance had a great flight of steps, on each side of which were two oversized ladies representing tragedy and comedy, sitting precariously on the back of two

very angry-looking bronze lions; the whole was surrounded by a wrought-iron grille, inside which was enough space for a few palm trees and busts of musicians. When I arrived for the first time in my life, I was disappointed when the carriage did not stop in front of the lions but drove straight through a tunnel into a circular, covered courtyard where we alighted. It was explained to me that only the *hoi polloi* used the front entrance and that, in the olden days, there had been a ramp that went up to the second tier to enable the carriages to deposit people by their own boxes (I never believed this).

Having alighted, we went through long corridors and up dreary stairs, which reminded me of the inside of a hospital, until at long last we emerged in the foyer. Here my disappointment vanished, or rather was drowned by the splendour of the room, four storeys high, in which palm leaves, laurel branches, masks both tragic and comic, musical trophies, eagles and flying ladies, gilt, stucco, bronze and marble, fought each other. At last we had reached our destination and I could see the great horseshoe hall with its five rows of boxes and the gallery on top, the Royal Box in the middle and the red velvet and gold curtain.

Now I must just explain the mystique, based on snobbery, of the five tiers of loges (the sixth or pigeoncote, as it was called, didn't count). The first tier, just over the stalls, was mainly occupied by different clubs, officers and their families, government and municipal personalities. The second tier was the most chic and expensive: here was the great gilt Royal Box surmounted by a huge crown, with the four boxes belonging to the smart Bellini club on one side and the Prefetto's on the other. The remainder was occupied by the cream of the Palermitan élite, each family renting a box for the season year after year. The third tier held the upper middle-class, the Bar and rich families with lots of daughters on the market who had not been able to get into the second tier and yet wanted to be seen. The fourth was the tier where people took refuge when they couldn't get into any other one, as it was supposed to be worse than the fifth. In this last, fifth, tier were those

occupants of the exalted second tier who were in mourning, which was quite often as mournings were very strict in those days; teenagers who couldn't be seen lower down because they were not dressed properly; and impoverished nobility who, not being able to afford the second tier, would rather not go at all than be seen in the despised numbers one, three or four. As for the stalls, it was simply unthinkable to be seen sitting in them, only lawyers or engineers with their bedecked spouses and strangers from hotels would use them. I recall that when I very much wanted to go to the opera later on when I was twelve, I was allowed to go after much sulking, pleading and weeping, but only into the fifth tier, whereas my dear sister sat far below lording it in the second tier.

However for the matinée of *Aida*, I was allowed to sit in the second tier in a loge rented for the occasion. Oh! that never-to-be-forgotten moment when the orchestra in the pit stopped tuning its instruments, the house lights went out, the conductor appeared like a Jack-in-the-box and *tic, tic, tic* went his baton on the music desk and majestically the great curtain opened to reveal a hall in the royal palace of Memphis ablaze with light. As soon as Radames started and the first blast resounded right through my breast, my destiny was sealed, the spell was cast, and I was forever fated to remain an opera fan. As the performance proceeded, my excitement increased. The dance of the Moorish slaves had me wriggling on my chair, and the triumphal march jumping up and down in a frenzy. The tribunal scene aroused my indignation and anger and, by the time Radames and Aida were buried alive under the temple whilst Amneris prayed over them, I had dissolved in a flood of tears. I had to be reassured that they had not really died but were in fact very much alive – because there they were bowing and curtseying to the applauding audience.

After such an experience the family had no peace until I was allowed to have a gramophone of my own. This became my pride and glory and, as the years passed, records were the presents I asked for more and more. The inhabitants of my dream world became Mimi and Rodolfo, Butterfly and Pinkerton, Norma and

41

Pollione – but never Hansel and Gretel: I had been dragged to that just because it was supposed to be suitable for children.

Grandmamá was a great admirer of the famous tenor, Francesco Tamagno, who had created the role of Otello. She had known him very well, had several photographs of him in his different costumes and told anecdotes of his extraordinary performances. How he had shattered two window panes with the force of his *Do di petto*, and how at the Politeama, having been forced to repeat several times the agonizing cry *'Miseria mia'*, he had become exasperated and so had cried to the public *'Miseria vostra ...'*, thus creating a near riot. According to her, no other tenor would be able to sing the *Esultate* or *Niun mi tema* after he died.

One more personal link between opera and my younger years. We possessed a large, soft cushion covered in pale-blue flowered brocade that was known as the *bellincioni* because it had been lent several times to the famous soprano, Gemma Bellincioni, for her to die on in the last act of *Traviata*. La Gemma, as she was known to her fans, was a very beautiful woman and a very elegant one. Many years later, I met her in Venice where she then lived. She was by that time an old lady with little trace of her former beauty except for her luminous eyes and a velvet speaking voice. She remembered the blue cushion perfectly and told me how once, in falling, she had half missed it and banged her head on the stage floor. Her house was on a side canal and the silence of it oppressed her after the hustle and noise of Milan where she had lived before. So whenever she could she would take the *vaporetto* to the Lido just to sit on a bench and listen to the screeching of the tramway and the honking of taxis, close her eyes and dream that she was in Piazza della Scala in Milan once again.

Not all my time was spent with Maria Felice, reading books, drawing or listening to music. I was often restless and energetic, longing to be out of doors.

In the garden there were two trees that were my own property and no other child was allowed to climb them except at my invitation. Both belonged to a variety of tropical gum tree called

ficus elasticus. Their trunks and spreading branches were made of elephant skin, the leaves were waxy and quite large. If you picked one, a sort of milky substance came out of the stem, which came in very handy when I was having a tea party up there. One of these trees, because of its height and a certain protruberance at its base that resembled a behind, was named Popo-cielo, and the other because of its knobs that reminded me of the warts on our family doctor's bald head, was called Arico after him.

Sometimes though, in spite of my vivid imagination, I exhausted every kind of excitement and I did not know what to do with myself. My sister had all her animals and her lessons to keep her well occupied and, anyway, didn't always want to be bothered with me. I was therefore quite often left to my own devices. At such times I would slip into my mother's room, plant myself in front of her or any other available grown-up and seriously announce, *'Bimbo disoccupato'* – which could be roughly translated as 'Child in need of an occupation'. Incidentally, my Mamá's pet name for me was, I shudder to recall, *'le petit flou'*!

What I really wanted was for my mother, or some other grown-up, to come with me into the immense wilderness of La Favorita park. We were really very privileged children, for not only did we have a big garden where we imagined every clump of trees to be a town and where each of us had a hut, but we also had this vast park at our disposal. I loved playing there with my friends and with Maria Felice, but it was rather too large for me to enjoy all alone. My mother could sometimes be persuaded to come with me, since she too had played in the park as a child: indeed, it had once belonged to the family.

In the eighteenth century the Kingdom of the Two Sicilies was ruled from Naples. However, by 1798, the French armies were advancing down through Italy, and King Ferdinand and his wife had to flee to their other capital, Palermo, under the protection of Lord Nelson. The Royal Palace in Palermo had seen the Arabs, the Norman Hautevilles, the Swabian Emperors, Charles of

Anjou and the Aragonese but, in spite of all this glory, it was a sad and gloomy place to live after the great palaces of Naples, Caserta and Portici, and the King was determined to have a country seat. Three noblemen who had adjacent estates in the I Colli region each presented him with part of their land so that he could have a spacious park and privacy. One of them was my mother's great-grandfather, the Prince of Niscemi, so that was why we had free access to La Favorita and could use the park and the formal gardens whenever we liked although they belonged to King Victor Emmanuel.

All that we had to do was to open a little door beside the gate and there lay the park with all its fascinating mysteries – copses of laurel, great oak trees and a fountain of Hercules which was full of green slime and therefore dangerous for paddling. In another part, there was a Greek (or was it Etruscan?) necropolis which was by far the most romantic setting for a game of hide-and-seek, especially with bewildered and rather frightened children visiting us from Palermo. In front of a strange, erratic-looking, gone-to-seed pavilion was a mulberry tree of gigantic proportions whose berries gave us terrible indigestion.

In theory, we were supposed to remain on the side of the main avenue that ran parallel to our garden wall and divided the park in two. Sometimes, however, we went across the avenue, either on our own after much pleading or with a long-suffering adult, and then we were able to climb up the rocks to the very base of that overwhelming Mount Pellegrino to pick blackberries or myrtle berries and to wonder at the Slave's Leap, a great protruding cliff. From the end of January until April, these slopes were covered with masses of wild lupin, anemones, freesia, daisies and a bright little red flower called 'the flower of St Joseph' as it bloomed around the end of March. Later, in early summer, wild mint and rosemary, juniper and jasmine, golden burnt grass and those pink rocks exhaled an intoxicating aroma which made you forget that there were supposed to be vipers around. As in all those years I never saw one nor ever heard of anyone being

bitten, I suspect that their lurking presence was invented to keep us away.

There was a gap in these cliffs, a very steep little valley, for some remote reason unromantically called La Valle del Porco, or Valley of the Pig; half-way up it was an abandoned little chapel-like hut where a hermit had once lived. We used to wonder what the connection might be between this hermit and the porker. Shades of St Anthony Abbot I suppose. In the autumn, armed with gloves and knives, we would go and pick prickly pears, carrying them home to put them in iced water as they were uneatable if warm.

The racecourse was also inside the boundaries of La Favorita and we often went to see Father's horses being trained or watch him shooting clay pigeons.

But of all the enchantments that La Favorita could offer, the marvel of marvels was the Chinese pavilion, Le Palazzina Cinese. Separated from the rest of the park, in the middle of a formal garden, there rose this strange accumulation of brightly-painted walls, porticoes, terraces at different levels, and pinnacles, all seeming to climb out on top of each other, surmounted by a roof in the shape of a tent – everything about it nonsensical. The ballroom was in the basement. A long barrel-shaped, ceilinged gallery, like a corridor with semi-circular endings with steps for the musicians, and on the walls a series of Bartolozzi prints cheek by jowl. Another room was painted to look like the inside of a ruined moonlit tomb with owls and bats. The dining-room, like a trellised terrace, was just big enough for a table for six which had seven holes in it: a big one in the centre for the main dish and six smaller ones for the plates. Directly underneath, in a kind of cellar, was a very complicated wooden machine that, by turning a handle, carried the plates up or down – the custodian, who was a great friend of ours, used to work it for us. I remember that there was still a faded piece of paper nailed to it with the instructions and an explanation of the different ways the bell could be rung to let those below know if they wanted wine, salt,

or bread. Here the King and Queen had their meals with some very honoured guest or intimate friend. In my imagination, I could see the Hamiltons, Nelson and Mrs Cadogan filling the four extra chairs.

There was also a grand salon, with painted Chinese silk panels and a red lacquer floor. The King's room, Turkish in style, was divided in three by a canopy in the middle and under this was a boat-like, iron red and gold bed. A sliding panel in the wall hid the washstand and a lower one the *pot de chambre* (the 'Miss White' as genteel Miss Lilley called it). A small spiral staircase led down to the bathroom, an octagonal marble *piscina* with miniature horseshoe steps. How King Ferdinand, who in all his letters complains constantly about his feet (*'Oh le mie pedamenta'*), could go up and down the stairs and in and out of the bathtub is something of a historical mystery.

The Queen's quarters upstairs had a Persian room and a Pompeian one. The first, in pale greens and silver with octagonal columns, embroidered ottomans and the most unexpected papier mâché chandeliers, dripping with strings and tassels of pearls. The Pompeian room had black shiny walls piped in red, with a frieze of dancing figures, animals and urns. This led into the Queen's bedroom, which was pale blue and white stucco and decorated with medallions *à la Wedgwood* with profiles of the Royal family. She had painted these herself, for Maria Carolina, like all the daughters of the Empress Maria Theresa, was an accomplished artist. Instead of writing the names under the portraits, she had used descriptive little phrases like: *'Il mio Sostegno'* (my support) for the King (in reality it was the other way round); *'La mia Speranza'* (my hope) for the Crown Prince; and *'La mia gioia'* (my joy) for her daughter Maria Amelia, later Queen of the French. There was also a larger oval medallion with several little angel heads floating among clouds and inscribed underneath: 'My lost hopes' . . . her miscarriages! Next to it a tiny reading-room: I don't think that she can have spent much time reading as there wasn't space for many books.

This very strange edifice was crowned by a tent-like, square breakfast-room with two large terraces, one with the view of Palermo that was more or less the same as we had from the villa, the other one looked towards the bays of Mondello and Sperrace-vallo and showed the cliff-like mass of Monte Gallo, arid and golden, rising from a green sea of orange groves.

In the grounds near this pseudo-Chinese folly were two long and narrow barrack-like buildings which were almost hidden by hedges; these were the attendants' quarters, one for the unfortunate courtiers and the other for servants. Also in the park was a round, white, pagoda-like chapel where my sister made her first communion.

In those days all still belonged to the King: the formal gardens were very well kept, the gates and grilles painted in bright colours and the little bells on them still tinkled in the breeze. In fact, the whole park was tidy and clean, and the fountains of Hercules and of Diana had water in them. (Today the first fountain is in ruins and the statue of the chaste Goddess, which for some reason remained headless after the First World War, vanished altogether after the Second.) In my childhood, the men employed to look after everything were royal servants and wore uniforms and caps with the crowned cross of Savoy on them. They all belonged to two or three families, all had their houses in the grounds of the park and were a dignified group, proud of their status. As I have told you, their daughters came to work for Grandmamá, we knew them very well and their young children were our playmates.

La Favorita never palled over the years as a wonderful place in which to play, but around the middle of June the weather became too hot for racing about. Then, much to our joy, the sea-bathing season began. At four o'clock in the afternoon we would pile into an open landau with a tent on top and start towards the beach of Mondello, a beautiful stretch of snow-white sand between sea and lagoon. The beach was quite deserted, being too far for the towns-people to come in those pre-motor days, but perfect for us, as it

was only a few kilometres from the villa. We used a row of wooden bathing huts erected every year on stilts: each cabin had a trapdoor in it with a ladder for the ladies, so that they should not, for modesty's sake, be seen entering the water until they were submerged to the shoulders. The owner of the bathing huts was a fat man called Badalamenti, who had a bevy of children of all ages. The one nearest my own age was my special friend and also my swimming teacher; all of Badalamenti's children swam like fishes. When she could, Mother also came swimming with us, while Miss Aileen sat on the terrace with a parasol and the dogs, ceaselessly warning us to keep out of the sun – for in those days the suntan craze had not yet started. Mondello was our paradise on earth and we soon bossed and tormented the few other children who ventured near, especially three neighbours of ours, of whom you will hear more later.

As the years passed, Mondello began to change. Hideous villas sprouted, mangy palm trees were planted in melancholy rows and a vast edifice on cement pylons rose from the water as monstrous as it was colossal. It is still there with its terrace, restaurant and dance floor but, compared with the hotels, apartment houses, restaurants and night clubs that now surround it, it has become almost venerable.

However to return to those golden days. After many shouts of 'Fulco, you will catch a chill', 'Fulco, it's time to come out' and 'Fulco, you have been there long enough', I would reluctantly come out of the sea to be rubbed with a towel and presented with a biscuit and half a glass of Marsala.

Around six or half-past, we would start to go home. I would climb up next to the coachman, turn my back on the horses and pretend to be a preacher in his pulpit. My sermons, though, were not always concerned with religious subjects. One was, 'The world is nothing but a great desert' and was all about hermits and tame lions. My favourite related the adventures of 'A naked hunter riding on the road to Cefalu'. My audience, being unable to escape my eloquence, soon became both impatient and exasperated, and

Maria Felice would try and pull me down by my feet, which she sometimes succeeded in doing.

So back home to tell Grandmamá about our aquatic exploits while we were at dinner on the terrace. How I had built a sand castle far bigger than anybody else's, how so-and-so had swum out after me which she was not allowed to do or how I had scared the wits out of Signorina so-and-so by suddenly biting her leg under the water.

5

ALTHOUGH the Villa Niscemi and La Favorita were the centre of our world, our own undisputed kingdom where we reigned supreme, there were in our young lives other houses and other gardens that were ours. Not to be compared, of course, with the one and only abode of our delights, but nevertheless part of our childhood. One of these was our own town house in Palermo. As a child, I was a rare and reluctant visitor but later on went there during the week whilst I attended the local day school.

In one of the oldest parts of Palermo, near the twelfth-century cathedral and the tombs of the Emperors and Kings, is a very narrow, steep, slippery street without pavements called Via Montevergine. As you walk along this street, across a small piazza with a church in it, it slowly begins to go downhill, and here, in this second part which is even narrower than the first, stood, and very precariously still stands, the Verdura Palazzo: an ancient,

vast, rambling conglomeration of buildings. The street was so narrow and the houses so tall that it would have been easy to walk right past it but for its enormous *porte cochère*. Ours was not one of those great eighteenth-century palaces. Much older, it mostly dated from the sixteenth century and was built on a maze of wide, low arches of a much earlier date. Most of these had been filled in but some were still just visible.

It was more like a Kasbah than a palace: three separate houses on the street but all communicating inside. Embedded into one wall was the elegant Church of the Three Kings with Serpotta statues. Once through the door of our palazzo there were three courtyards and several other small yards known as *pozzi di luna* or moon wells, a terrace and a garden. Across the garden a pink house also formed part of the whole.

Of no particular architectural value, the Casa Verdura had a patchwork charm. It may be hard to believe, but I have never set foot in some parts of it in all my life, for instance, I've never been inside the pink house I have just mentioned, though I have gazed at it for years from my own apartment. I say Casa Verdura and not Palazzo because it was supposed to be common to use the second word when referring to your own house. Tradespeople and servants used it. On the other hand, our elders expected to see it written in the addresses on letters, and would have had hysterics if they had received an envelope with a mere *casa* on it or, even worse, the number of the street. I remember Mamá getting a postcard addressed to *La Duchessa di Verdura, Palazzo proprio, Palermo* – The Duchess of Verdura, Her Palace, Palermo . . . *autre temps autre moeurs*.

One entered through a great archway into a barrel-vaulted passage large enough for the biggest carriage. On the damp walls, stone and marble coats of arms and tired-looking palm trees underneath. Strangely, this grandiose entrance led into a courtyard which was so small that a carriage would only just have had space enough to turn around in to enable it to get out again.

The denizen of these precincts was an old retainer named

Piddu. So ancient was he that, after knocking at a door to come in, instead of the usual: 'May I come in?' or '*Permesso?*' he would exclaim in a cracked voice, '*Deo gratias*' and, during the month of May or the several religious dates dedicated to the Virgin Mary, '*Viva Maria*'. As soon as some visitor arrived, he would totter as fast as he could to pull the chain of the bell by the staircase. As he was very deaf he did not realize that, by pulling it with such vigour, the peal was loud enough to raise the dead. There was a special protocol about ringing this bell to announce visitors: one stroke for gentlemen, two for ladies or couples, three for members of the family, four for the master and the mistress. For the clergy a special compromise had been devised: a priest, in acknowledgement of both his sex and his robe, was entitled to one very loud stroke followed by a gentle tinkle. (When my father died, I was in Venice and got back just in time for the funeral. There was great confusion in the house with relatives and friends milling around, and of course no ringing while his body was still upstairs. It was only when I came back from the chapel, as I was going up the stairs, that for the first time I heard the bell ring four times for me. But that was when I was a young man, and has nothing to do with these childhood memories.)

Before we leave old Piddu, I must tell you about his sneezing fits. His sneezes were so loud and prolonged that he had to be sent to the nearby Piazza Montevergine and he was not allowed to return till after the spell was over. On those days the doors were always open and anybody could, and did, walk in.

The staircase of Casa Verdura was rather imposing but, in spite of two enormous mirrors, marble steps, glazed stucco walls, a vaulted ceiling and a life-size, half-naked, seated female holding an urn on her knees, looking at you with a soulful air, it all suggested the adit to some strange mausoleum rather than the entrance to a house where people were supposed to live. On each side of the staircase walls were four gilt lion heads with rings in their jaws. Through these went two red velvet ropes with gold tassels. Seventeen wide, low steps led to the melancholy female.

I had two ways of ascending them; by running up as fast as I could to reach the top landing before the third stroke of the bell had sounded or, if allowed, pretending that I was an Alpinist climbing the Jungfrau, by clinging to the rope and resting at each lion head. This was after we had spent a month in Grindelwald.

Father's part of the house had its own means of access and this grand marble staircase was rarely used, so that as you emerged into the entrance hall a dusty, musty, and thank God rather faint, smell met your nostrils, as it was called by Mamá, the smell of the dust of centuries. This first room echoed the funereal atmosphere of the stairs: marble floor, glazed stucco, marmoreal walls and huge inlaid stalls from some chancel that should have been in a church. Next, a cavernous room with a *cassettone* ceiling, ancestors, quite ugly, on the wall and Renaissance *cassoni*. Hence to a drawing-room full of china, Murano glass and all kinds of *bibelots*. Pictures of course, bronzes and chandeliers. All these things were reflected in smoky old mirrors like black, crepuscular lakes. There were also some pretty Louis xvi rooms with charming ceilings and *boiseries*, but, as the windows were never opened, it was so dark one could only guess at them. Finally, after exploring these sombre meanderings, you emerged into an enormous hall known as *La Galleria*. Here, Nicola, Father's bewhiskered and bad-tempered butler-cum-cook, with great turning of rusty keys and unbolting of bars, would open the three tall windows on to the terrace and let the sunlight pierce the dancing dust to reveal a strange *mise en scène*: red walls that were literally covered, wall to wall, floor to ceiling, with vast, impressive pictures in dull gold frames. They were the most lugubrious lot imaginable, Mary Magdalens with skulls and long hair, St Jerome with his lion, St Anthony with his porker and various other eremites all indulging in their favourite pastime of hitting themselves with a stone or just gazing, half-naked, into space.

We also had a great stormy seascape with a ship smashed against the rocks, St Peter crucified upside down and St Andrew attempting the big split. The two most terrifying paintings depicted the

martyrdom of a saint being disemboweled in the most realistic manner while around him horrid Roman legioneers gloated and above, in the clouds, angels cavorted; the other was the severed head of St John the Baptist on its silver platter. His half-closed eyes were painted in such a way that they seemed to follow you as you moved, with the most disconcerting effect. This piece of poetical bravura was, with no evidence, said to be by Caravaggio. There were many fanciful attributions in this collection, as all the good pictures had been sold long before my appearance.

In a lighter mood, there were pictures of dead fish, barnyard birds, a few madonnas with child, and also a great big panel with Orpheus playing his lute for an assortment of life-size animals: the most conspicuous part of this composition was the rear side of a piebald *percheron*. As a companion piece on the other side of a door, a group of dishevelled females and lustful satyrs cavorted around in a vortex of purple grapes and fractured water-melons. All these strange personages and animals gazed from their frames on to a multitude of disparate furniture, Louis xv consoles, tables covered with books, *buttoned* sofas, a large stove and a set of black horsehair-covered chairs.

In the midst of this crowd stood a grand piano of ancient lineage. On this formidable Erard dated 1840, and never quite attuned, my reluctant sister was supposed to practise her scales after her music lesson, while up in the library some priest tried to reconcile me with Latin or make me solve the mysteries of arithmetic. At school in Palermo, I was a discouraging failure at almost everything except French, which I spoke far better than the teacher, so a series of clerics were engaged to give me extra coaching; they came and went as I tried, and succeeded, in driving them to desperation and departure.

I remember two incidents that hastened this desired goal. I had been on such terms of familiarity with one of these hapless pedagogues that, instead of shaking hands with him, I was seen extending my foot in greeting – and, since the first encounter, I had flatly refused to kiss his tobacco-stained fingers. The other

incident was really caused by my mother's being wounded in her motherly pride. A padre, whose name I obviously can't remember, was complaining of my stubborn resistance to Latin. To which she exclaimed, 'Now look here, Padre, you're not trying to tell me that Fulco is not intelligent?' 'No, *Signora Duchessa*, he is not intelligent, he is vivacious.' . . . So, she had to let him go.

Via Montevergine, before I went to live there, was a source of fascination intermingled with a sense of awe. Its darkness and silence so far removed from the bustle and light of Villa Niscemi both frightened and intrigued me. When I had time between lessons, and also I must admit, in order to delay as long as possible the moment of truth, I would tell myself to be courageous and start to make forays into the unknown parts of the house. First, I explored the so-called library, a suite of four or five rooms full of dusty old books, portfolios of prints and drawings, volume after volume of the *Illustrated London News*, stacks of old newspapers and gazettes dating back to the late eighteenth century, some repulsive-looking fossils and old bones, a few stuffed animals and, on a round table, photograph albums full of angry-looking gentlemen, bewhiskered and top-hatted, peering over the heads of melancholic ladies in crinolines. Then I had a choice of vast attics to explore, all full of the most extraordinary bric-a-brac, old beds, frames, chairs, chess boards and God knows what else. In one, I discovered, in a wooden box, a man's fur coat falling to pieces and bunches of dead flowers that disintegrated as I touched them. These were, I learned later, the relics of Uncle Alessino who had died very young, long before I was born. That put a stop to my visiting that part of the house.

There were also the archives of the families that had entered into mine. Downstairs on the ground floor under those ancient medieval arches on which the house rested were the Cerda papers in wooden boxes. The Verdura archives were in a completely different part of the house; these I could peruse at leisure, while the ones downstairs were locked up. Leafing through them, I found out about the past existence of a family called Leofante

whose coat of arms was a funny little elephant; another one was simply called Imperatore and modestly claimed descent from Iulius Caesar Imperator . . . just that.

On the first floor next to the *galleria* was a delightful drawing-room, that we later used as a dining-room, with white and gold *boiseries*, yellow damask walls, a painted ceiling and a Murano chandelier. It looked quite inviting with its great Aubusson carpet, marble chimneypiece and mirrors, but, if you opened one of the doors, you were confronted with an altar and a leaning crucifix surrounded by a plethora of holy relics in silver frames. The presence of death again. For an inquisitive child like me, the Casa Verdura was more than just a house to live in, it was an unknown world to investigate and probe into, and always I was reassured by the knowledge that, in the evening, I would go back to the embrace of my beloved Villa Niscemi.

But all was not gloom at Casa Verdura because there was a terrace and a garden. The former had an iron trellis sagging under the weight of a strange tropical creeper with greenish-white trumpet-like flowers and hanging roots that looked like elephants' tails. Fighting this West Indian invader was a venerable wisteria that seemed, every spring, to lose ground. A little winding cast-iron staircase was so tangled up in the roots and branches of this impressive plant that it was hard, at least for me, to distinguish the mineral from the vegetable parts. The garden itself, small and surrounded by high walls, had assumed the aspect of a miniature jungle as plants and trees stretched upwards in search of the sun. Under a parasol pine tree grew, in utter disorder, syringas, pomegranates, hibiscus, Japanese medlars, and inedible bananas. On every bit of wall not invaded ivy, jasmine, honeysuckle and morning glories grew like weeds.

At that time, I did not understand this unexpected little oasis and, thinking of the glories of the garden at the villa, I despised it. It was only later when we actually moved into Casa Verdura, heavy-hearted and sad, that I began to appreciate it. I had been put in a stuffy little room that I hated. But it had a French window

on to the garden and a datura tree actually leant against the panes; when I opened the window on some hot summer night, a branch laden with wonderful moonflowers would come right into my room and lull me to sleep, contented with the thought that, if I had lost much by coming to live in town, at least the scent of the datura of Casa Verdura was not mingled with the aroma of those horrid old baboons. After all I have tried to describe, it is little wonder that we didn't have much affection for this, our ancestral home, for it represented all the bad sides of my life: lessons, routine, indoors and a sense of oppression.

Poor old Casa Verdura had two direct hits during the Second World War and one bomb fell on the part of the house overlooking the garden, the pine tree fell on what remained of the terrace, but the datura somehow survived and it is still there, opening its large, lunar-scented chalices at night in the reborn garden. . . . The poor palace may be but a deserted, empty carcass, but now that the walls have opened up and the pine tree has long gone, the garden, which is said to be on the site of an Arab cemetery, is full of light and sun and the jasmine and honeysuckle smell sweeter than ever.

There was also a third house that played a definite part in our childhood life, the Villa Serradifalco at Bagheria, on the other side of the Bay of Palermo. It belonged to Father and had come to him through an inheritance. Bagheria was roughly to Palermo, what Frescati was to Rome: a big borough dotted with gardens in which stood the sumptuous villas of the nobility. Some very, very grand like the Velguarnera, Cattolica, Trabia, Butera San Marco, Cuto; some smaller, all on one floor, with terraces and pavilions and, of course, the one and only Villa Palagonia with its monsters. It has been described so very often, by Brydon, Goethe and so many others, that it is useless for me to do it here once more.

Our villa was just in between the grand and the smaller ones. It was seventeenth-century, but had been remodelled at the end of the following one. A double staircase led to the entrance, but its

counterpart at the back was at ground level, as the villa was built on a steep slope that very soon blossomed into an enormous rock, known as La Montagnola, which was crowned by an obelisk. I don't know how high this rock was, but our great boast was that it was higher than the one in the Valguarnera gardens. The house itself had five big balconies on the façade and four on the sides. The stairs led to a big hall with some very poor portraits of the singularly morose Serradifalco family. All the other rooms were square, exactly the same size, with vaulted ceilings and white-washed throughout, except for the drawing-room, which was in fact a library with oak panelling and black horse-hair furniture, the only open fire in the house and the only full-size carpet. The other rooms were bedrooms with the barest minimum of essential furniture: a bed, bedside table housing a pot, a chest-of-drawers, chairs and, in the most luxurious ones, a couple of armchairs and perhaps a mirror-fronted hanging cupboard. No trace of a bath-room and, as for the only two so-called WCs, they belonged to the Paleolithic Age.

I didn't mind so much about the washing, as tubs were brought in and we only stayed there in summer, but I had to think twice before confronting the hazards of the lavatories. Even so, it was easier for me, being male, than for my sister: for me there was always out-of-doors. No electric light of course, but in every room, except the drawing-room which boasted a chandelier, a contraption hung from the middle of the ceiling which was lit with acetylene. It gave the most vivid and livid light that attracted every kind of flying denizen of the night except mosquitoes as the house was on a high hill and as dry as the proverbial bone.

On one side there was a vast courtyard surrounded by low farm buildings: the estate had an olive grove and some vineyards, almond and huge fig trees. In these bucolic, if somewhat wild, surroundings Father turned into a gentleman farmer. Attired in a white linen suit, boots and straw sombrero, he busied himself, with great gusto, in whatever activity the season demanded, crushing olives or grapes for his oil and wine, delivering cows,

shooting quail or hare. There were also paddocks for the race-horses, Gallipoli, Melton, Pylsener and Bolero, who spent the summer months here.

For me, the great attraction of Serradifalco was the *montagnola*; to me it seemed to be an enormous mountain, and all mine. Full of harmless snakes, lizards and geckos, with its crags and boulders it would have been an ideal place for all kinds of rough games but, alas, I was alone on it because the few neighbours we had were mostly girls and much too tame. From the summit of this tor, the view was unbelievably beautiful as it stood saddled between two rocky mountains, bare and forbidding. On one side of the Bay of Palermo with our own dear Monte Pellegrino in the distance and, at its feet, shimmering in the summer haze, the great white city: on the other side the coast dotted with towers and castles, Solanto, San Nicola, Trabia, Torri di Termini, towards Termini and Cafalu, and the blue sea, the russet and green of the coast and the mauvish tints of the mountains vanishing together in the heat.

We used to go to Bagheria for a few weeks in July and some-times again in November. Nowadays it takes about fifteen minutes to get there by car, but then it was quite an adventure and we went by train with dogs, maids and a highly-disapproving Miss Aileen. At the station we were met by an ancient four-wheeled contrap-tion with a fringe on top, called a *papone*, Father on horseback and two fierce-looking individuals, also on horseback, with guns. These were the *Campieri* and they came with us whenever we left the grounds of our house. I think it was a case of 'who is master here' more than anything else, as the Mafia was of a different kind then and we were in no danger of being kidnapped. The Mafia fought between themselves, bitterly and savagely, but had no con-nection with the city or the townspeople. At least that is what I was told.

It took about half an hour to climb up to the villa on terrible roads in a vehicle devoid of springs, but we eventually got there, more dead than alive, delighted to reach if not comfort, at least complete liberty. No lessons of any kind, no definite hours for this

or that, and figs to pick warm from the sun and eat till they made you sick.

The first thing we did was to ask Agostino, the farm manager, about new arrivals, how many foals, calves or kids? Any new dogs? How many rats had Spot, the terrier, caught? Had that strange cat wandered away again? As soon as our curiosity was satisfied, before even entering the house, we had to rush and climb the *montagnola* (*montagnola* stands to *montagna* as doglet stands to dog, so I suppose it could be translated 'mountlet') to make sure that nothing had changed and the view was still there.

One, never-to-be-forgotten year, there was indeed a great surprise in store for us. Living in the house as a guest was a young Somali boy more or less my own age. He was the son of some chieftain in the then-Italian Somaliland. Why my father had invited him to stay or what it was all about, I have to this day not the faintest idea. Anyhow, there he was, dark-skinned, tall, lithe, with perfect manners, dressed in a white tunic with a blue sash around his waist and a high tarboosh on his head. He looked very handsome and aristocratic and his name was Abu-ba-Ker.

You can imagine our excitement, especially mine, at having such an unusual playmate and also anticipating the pride of telling this extraordinary piece of news to my friends in Palermo. I enjoyed helping him put his sash on as he couldn't do it by himself. He would stand as far away from me as the sash was long, holding it on his stomach while I held the other end, then he would twirl around towards me in a straight line, very rapidly tucking in the end in such a perfect way that it never made a pleat. However many times he helped me try to achieve the same result on my person, I failed miserably. We became great friends and I really loved him but, in time, a slight element of envy crept into my heart, for he was much taller than I and far more adroit at climbing trees and jumping from rock to rock on the *montagnola* without ever scratching himself, while my poor, short legs were one mass of bleeding scars. I wonder what happened to him.

The governess did not approve of our friendship, although

Abu-ba-Ker was a guest and not a servant. It was difficult to understand him as his Italian was sketchy and highly original. On one occasion he asked who were the *Ascari-gallina* he had seen running through a field. They turned out to be a group of *bersaglieri*, the corps of the army that wore a bunch of roosters' feathers on their hats and marched at centre-speed. It made sense as *Ascar* in Somali meant 'armed men' or 'soldier' and the nearest he could get to the feathers was *gallina* – hen – a word he had learned in the barnyard. He devotedly said his prayers turned towards Mecca. How he knew in what direction Mecca lay was a cause of great amazement to me. Once Father discovered me trying to tell him that he was doing it all wrong and that the real direction was that of the pig sty. I was severely scolded and was obliged to beg his pardon, a completely useless humiliation for me as he hadn't understood a word of what I had tried to tell him.

In the grounds of Serradifalco there was a long farmhouse full of old, crippled, mangy dogs that Father had rescued from the streets. They were supposed to be looked after by a strange Scotsman of whom I remember little, not even his name, and who eventually disappeared, taking with him the meagre contents of the till. You see, what with Somali boys and hospices for stray dogs, there were very few dull moments when my father was around. On the ground floor he had arranged a dining-room which was very cool in summer and which looked like a cellar. On the walls were pasted enormous posters of operas: Tosca putting a crucifix on Scarpia's dead body, Madame Butterfly committing *hara kiri* and so on. Great was my fascination and undoubtedly this extraordinary room helped me to keep alive my love for opera that had begun with my visit to *Aida*.

At Serradifalco we played games that we could not indulge in at the villa at Colli. A huge black snake had been killed, we had gone to see it and been most impressed. So, later on, we went back, picked it up and brought it back to the house; then, while the maids were having their dinner, we coiled it very realistically and artistically around one of the maid's chamber-pots and, with bated

breath, waited behind her door for the great moment. We heard her undress, take off her shoes and open her bedside-cupboard: an earsplitting scream, a thud and nothing more. The poor creature had fainted dead away and, while every denizen of the house was running around to see what had happened, we quietly slipped back into our beds and pretended to be asleep.

As Maria Felice was the elder and made more fuss of my father than I did, she always got the best of everything. When there were photographs being taken, she was always in the foreground petting a cow, fondling a calf or posing with Diana, the setter, surrounded by her litter of nine, while I crept round to the back trying to ensure that I would at least be in the picture. When we went riding, Maria Felice always rode Pylsener while I had to be content with old Bolero, if I had a ride at all. There is, in fact, a faded photograph of her, on Pylsener, hair down to her waist, panama at an angle, smiling in all her glory, while way in the background you can see an eager little face that had climbed on to a wall in order to be in the picture at all.

But once there was a great occasion when all the glory was mine, when I alone rode aloft on something far grander than Pylsener.

Father had been to Africa – I don't know which part of that continent he had visited – but one day, whilst we were at Bagheria, he told us that he had bought us a camel which would soon be arriving and which was to live in the empty paddock next to the horses. Personally I didn't believe him, for he was a great fibber and exaggerator, but Maria Felice accepted it as she did everything else he said. Weeks and months passed and no more was heard; by this time we had returned to the Villa Niscemi.

One morning we were called to the telephone. It wasn't often that we children had a telephone call. After asking: 'Are you alone in the room?' – 'Don't get excited' and 'Can you keep a secret?' he announced to a rapt (Maria Felice) and awed (Fulco) audience – I was holding the other receiver – that the camel had arrived and was drawing crowds at the harbour on the pier. It was on its way

to the villa at Bagheria, but, for some reason unknown to me, it could not be taken there till the next day and meanwhile somewhere had to be found for it to spend the night. The house in town was out of the question as there was no stable for it and it would have caused a riot anyway. So if he had it brought to the Villa Niscemi, say around five or six while the 'Ladies' were out, could it not be 'sneaked' into the stables till the next morning when, bright and early, it could be moved on to Bagheria without anyone being the wiser? Of course this highly impractical plan was instantly adopted.

Then a council of war was held; should we or should we not let fat *Gnu* Antonio into the secret and get his connivance? Was he trustworthy enough? We finally decided to let him into our confidence. Then followed hours of trepidation and fist-clenching self-control. More than anyone else, Miss Brennan must not know and it was very hard for me not to tell her as I loved her and always shared every trouble and excitement with her. How terribly difficult also not to announce it to the maids or one of the grooms: 'By the way, at five o'clock, a camel is arriving led by an Arab.'

It was a lovely April day, not a cloud in the sky. A smell of orange and lemon blossom was in the air and the jasmine creepers were just beginning to show the first little scented white stars. All was calm, except within our chests where hearts were thumping in expectation. The noises that came through the open windows from the courtyard were the everyday ones, but we strained our ears to detect the fuss that always accompanied the harnessing of the horses to the landau that would take Grandmamá and Mamá to town for their round of visits. Tea was served – Grandmother insisted on this little English habit that pleased no one except the governess – and still there was no sign of hats, gloves and other articles that suggested the nearing departure for Palermo. Then Maria Felice's insinuating voice asked, 'Aren't you taking the carriage today?'

'No.'

'But it is such a lovely day.'

'That is just why, I want to enjoy it here.'

A pause fraught with premonition. 'But didn't you have a fitting at Madame Durand's?'

'It can wait.'

Silence, broken from time to time by Miss Brennan murmuring the word 'disgusting' as I ate my strawberries and cream.

Then, like the incoming tide at Mont St Michel, a strange, muffled noise could be heard, coming nearer and nearer. Slowly it became clear that it was the roar of a rather large crowd approaching. Grandmother, pondering what would be the right behaviour towards the howling mass at her gates, did not get up to go to the terrace. With outward exemplary calm, she rang the bell. The bewhiskered Angelo appeared.

'What is the meaning of this?' she asked in an icy voice.

'I don't know, your Excellency, there seems to be a crowd at the gate.'

'Go out at once and what see they want and what it is all about.'

In silence the whiskers stepped out on to the terrace. The noise grew louder, punctuated with applause. Grandmamá stamped her feet, Mamá remained cool-eyed, Maria Felice tried unsuccessfully to look detached and I was ready to faint with apprehensive excitement.

Angelo came back and solemnly stated: 'Your Excellency, it is a camel.'

Then, as if timed by a stage direction, we heard it: a weird noise like the gobble of a gigantic turkey.

Grandmother rose. 'What camel! How dare you!'

Another gobble, gobble and out on the terrace we all went to see the noble sight of the camel and its keeper, alas in mufti. As we appeared, the crowd broke into applause. By now, there was some member of the household at every window, the dogs were barking and the whole villa had come alive with irrepressible excitement.

Maria Felice had to explain the truth. Grandmamá, thundering, had to accept the inevitable, and, like some queen granting the constitution to her people, gave the order to open the gate and let

the camel in. It wasn't easy, though, to keep the crowd out, but, with the help of all hands available, it was accomplished and the gate was closed once more. In the meantime, the animal, the Arab – a totally mute personage – and Ciccio, Father's groom, who had led the party from the boat, had entered the courtyard. Maybe it was the palm tree that made it homesick or simply bewilderment, but Moffo, as the camel came to be called (because of its resemblance to a friend of Father's), started his extraordinary braying over and over again, provoking panic amongst the denizens of that precinct, horses, donkeys, mule, all started an ear-splitting, cacophonous orchestra. I went down and was allowed to pat the beast and meet the mute Arab. Maria Felice instantly wanted to ride it and was restrained by an indignant governess. Eventually it was put in the stable.

No one slept very much that night, for the restlessness, neighing and kicking of the frightened horses never quite subsided, and the crowd outside the gate decided to turn the occasion into a party and settled round a bonfire with guitars and mandolins. They even built a couple of tents with old carpets. Their folkloristic din continued until dawn.

I think there must have been a very lively exchange of words on the telephone between my parents as to the duration of the animal's visit, because I was woken up bright and early the following morning and was told that if I wanted to see the camel before it went away I'd better get up immediately.

Thus came my moment of triumph, when, sitting on the camel's back with the Arab behind me, I made my appearance, in the dazzling morning light, to the plaudits of the populace. Alas, after a few yards, I was ignominiously put down by the mute African and led back indoors by the indignant governess, red in the face and muttering, 'What a way to bring up a child!'

By what means that beast was taken to Bagheria, a good twenty-five kilometres to the other side of Palermo, I really don't know, but it arrived there in perfect safety. The Arab disappeared and Moffo would probably have peacefully ended his life in the large

65

paddock there if a circus had not come to town and if Papa had not greatly admired the lady Amazon *de haute école*. These two events, seemingly unrelated to camels, changed the whole life of that vagabond quadruped. Instead of remaining a country gentleman, he was destined to become an itinerant trouper. The Amazon did her number in a tight-fitting black habit, top hat and long veil, riding side-saddle on a white horse. The sight of her doing the *pas espagnol* or the waltz proved to be irresistible to my father and, to get better acquainted with this equestrian siren, he organized a charity evening in which the performers were all amateurs. Several of the local gentry did, or rather tried to do, their best: there were cyclists; young ladies with trained dogs; a young man in his mother's sequin evening dress, feathered hat and feather boa driving a *sulki*; Maria Felice on the Amazon's daughter's pony picking up a handkerchief with her mouth. But the climax was the spectacular entrance of Father in full sheikh regalia on our camel. As he was very dark, slim and handsome, the costume suited him perfectly, which he knew. He took advantage of the situation, he stalked elegantly around the ring and finally made the animal kneel and bow its head as he jumped down to receive the applause. The evening was such a success that it had to be repeated the next afternoon so, at a Sunday matinée, I was able to see it and, in consequence, nearly died in an agony of envy.

As a parting token of Father's admiration when the circus left, Muffo was presented to the Amazon: so off they all went, caravans, cages, in a cloud of dust. Years passed. How many, who knows, as in my memory everything seems to be telescoped together. At any rate, the remembrance of our humped friend had faded away; other points of interest had materialized.

Then one rainy October afternoon in Paris in the rue S. Honoré, as we were hurrying to get under the arcades of the rue de Castiglione, we passed the Cirque d'hiver on our right; glancing up at the rain-stained posters, my eye caught the words: *Moffus Le Seul Chameau Musicien*. Could it possibly be? But it must be! So, rain or no rain, we had to stop to find out. And, sure enough, *la*

célèbre Amazone avec Sultan et les douze petits poneys had the same name, now forgotten, of Papa's flame. So we went to the Thursday matinée and, lo and behold! it was our Moffo. By this time, he had learned a great many tricks which he performed with the ease of a seasoned ham. Finally, he revolved on a sort of drum and, through a trumpet fixed to his mouth, he emitted a few blasting if equivocal noises. The young lady dressed as an odalisque who presented him was the daughter of the Amazon equestrian friend of my father's whom Maria Felice had known in Palermo.

The performance ended with twelve polar bears coming down a chute into a pool of water, and afterwards we went backstage to be greeted with effusion by Madame and her two children. She eagerly asked after the health of our dear father and took us to see the animals; we were allowed to shake hands with the famous clowns, Futit and Chocolat, were given some very ancient bonbons, and finally found ourselves nose to nose with dear old Moffo hoping for some sign of recognition. But he looked through us with dead eyes and turned his head away. We asked why they had changed the ending to his name. The answer came instantly: because it's more distinguished.

We walked sadly home to our hotel followed by Sandrina – Miss Aileen was in Ireland – who disapproved strongly of her charges consorting with acrobats.

6

ON 28 DECEMBER 1908 at five o'clock in the morning, one of the worst earthquakes that ever happened completely destroyed the town of Messina on our side of the Straits and Reggio and Villa San Giovanni on the Calabrian coast. To tell the truth, I didn't feel it or know anything about it. It seemed to be a day like all the others with the excitement of Christmas still in the air. The Christmas tree (imported at great expense) was still up on the *Stanza del Telefono* with some unopened presents lying beneath it. Yet the grown-ups must have been uneasy and worried: they knew there had been an earthquake but nothing else, as all communications with Messina had been cut; there was no telephone or telegraph, and though trains left from Palermo station none had arrived. My father telephoned in the afternoon to say that he was leaving with the Red Cross. As the day advanced all sorts of rumours started, but still nobody suspected the immensity of the

catastrophe. The telephone never stopped ringing from town. Grandmamá had the set face reserved for grand occasions and Miss Aileen was a bit fidgety, but for us children it seemed like any old rainy winter day.

It must be explained that Sicilians are always aware that earthquakes and eruptions may occur at any time; although Palermo stands on rock and is about 130 miles away from Messina as the crow flies and 110 miles from Etna, still one is conscious of certain very unpleasant possibilities. In point of fact that summer, while we were away travelling in Europe, there had been several hundred slight tremors, at least so Father had written to us from Bagheria; he had even sent us several snapshots of a tent made of old carpets in which he slept. But then he was a great dramatizer. Anyhow, there we all were about six o'clock on the afternoon of the twenty-eighth, Grandmamá, Mamá, Miss Aileen, Maria Felice and Fulco around a table, busy over a jigsaw puzzle representing the meeting of Dante and Beatrice (1500 pieces); Christmas tree in corner, dogs snoozing, birds chirping away in their two cages, rain dismally drumming at the window panes. All seemed still and quiet. Then the birds stopped singing. Mamá got up, we all looked at each other, all of us feeling a terrifying emptiness inside as if the blood had been drained out of our bodies. The three dogs began a deathly howling; a distant rumbling noise, not unlike the sound Grandmamá's carriage made entering the *porte cochère*, seemed to be resounding from under our feet and, in one second, everything shook. The table started to heave and most of the jigsaw pieces were thrown to the floor, books flew from tables, the chandelier waved and seemed to be on the point of crashing down. Mother screamed, 'The children under the window archway!' Easier said than done, as we were one and all literally paralysed with fear, and could not move. The quake must have lasted only seconds, but now, after so many years, it still seems as if time stood still in those seconds, enabling us to envisage the whole majesty of primeval fright.

This was the second and even stronger quake that finally

destroyed whatever had been left standing after the first one in the morning. As soon as it was over, everyone started putting out the lights (why?), running about, giving orders but not obeying them; we eventually found ourselves out of doors in the middle of the courtyard where all hell had been let loose: horses panted and snorted whilst grooms pulled them out of the stables, the maids, the cook and his kitchen and scullery boys, the whole staff were shouting their experiences at the tops of their voices. As we got out there, one last, small spasm as a reminder that all might not be quite over, made those in power (Grandmamá and Mamá) decide that all had to spend the night, whether they wanted to or not, out of doors – I can't remember if, how or where we had dinner, but I vividly recall the excitement of spending the night in a vast landau in the middle of the courtyard.

The next morning, the terrible news began to filter through; the number of dead and wounded kept increasing, the tales of havoc and desolation piled in a terrifying crescendo. The first to arrive at the stricken city was the Russian fleet which happened to be cruising near Malta, and they were the first to convey to the rest of the world the immensity of the catastrophe – eighty thousand dead in Messina alone, the magnificent seafront of marble palaces completely destroyed, the fire, the looting, the desperate cries of people under the debris of their own houses, the children wandering along half-naked, the dread of disease and a detail that, at the time, struck me most of all, the dogs that had to be destroyed.

The town of Palermo rose to the occasion and prepared to receive thousands of wounded and refugees. Mamá and Grandmamá spent their days at the hospital and came back exhausted with sad stories of orphans and lost people. Father came back with an orphan, a little girl called Lia, a whimpering, frail child who was eventually placed with some nuns; I remember years after her complaining that she had had a bad year with few funerals, these being the only occasions when the wretched orphans were taken for an outing.

My mother also came home one day with an orphan, a little

girl, also called Lia. She had had her arm amputated, was pock-marked, singularly ugly, but lively, gay and completely unaware of her sad plight. She eventually returned to her native Messina, I cannot remember why or how. There were so many Lias in Messina because 'Lia' stands for *litteria* which, in turn, means 'letter' in ancient Sicilian parlance. Apparently, the Virgin Mary was so attached to the Messinesi that she wrote them a letter in longhand, assuring them of her perpetual love and protection. One shudders to think what would have been the fate of the town if it hadn't been the recipient of this famous letter, for it has, in the course of the centuries, been destroyed several times by earth and sea quakes, and was bombed in 1848 by the Neapolitan fleet, thus giving to the monarch who gave the order to fire the title of King Bomba.

But to return to those black days, it was extraordinary to ob-serve that the people who had lived through such a nightmare, who had lost everything and everybody, had only one desire: to go back. In fact, by cart or otherwise, they all went back as soon as they were allowed to, preferring to live for years in tents and makeshift huts so long as it was back home. I distinctly remember being taken to a party at the hospital the following Shrove Tuesday, and there were the Messinesi on crutches, in their beds or on chairs, dressed in funny paper hats, throwing confetti at each other and blowing trumpets, with utter unconcern.

There is one story about the Messina earthquake that deserves the pen of a Maupassant to do it justice, but here it is. In our circle of family, friends and hangers-on, there used occasionally to appear the singularly unsavoury face of a certain priest; he shall be nameless as he had the unfortunate reputation of bringing ill-luck. In other words, of being *iettatore*, an unwilling harbinger of disaster. Imagine an empty, spotty old black cassock with a dusty hem and missing buttons. From this loose garment emerged on the north side an ivory hook of a face with two beady pink eyes and a few red hairs. To the east and west, two hands with filthy nails like the edges of mourning visiting cards. To the south, to

complete the portrait, a pair of black, antique, gondola-like shoes perpetually white with the dust of the highways. What was unpleasant to the eye was no sweeter to the nose. On top of it all his name had a certain affinity with that of an Italian cheese which was a coincidence that didn't help.

This clerical bird of ill-omen, whose connection with the house I never quite understood, as he was most unwelcome and made everyone reach for wood, horns or other amulets as soon as he made an appearance, had a sister, a younger sister who was supposed to be my mother's godchild. Apparently she was no beauty either, but, God being merciful, she managed somehow to get herself betrothed to some courageous, short-sighted young lawyer. Mamá, of course, had to give a wedding present and, not being noted for her largess in such matters, found a repulsive piece of mosaic representing a bird bath with a couple of pigeons in it, had a pin stuck behind it, put it into a box with some fancy Paris address on the cover and gave it to the enraptured bride-to-be. Proudly wearing this memento of Mother's stinginess, Mrs Young-Lawyer would come annually to pay her respects to her reluctant godmother and wish her a happy new year. The years started their inexorable and exasperating procession. The young lawyer began to have clients, with the clients came money and, with the money, a noticeable improvement in his better half's appearance. Every visit, something new had been added: frills, reticules, gold chain, fur tippet, gloves and, finally, the feathered hat, emblem of turn-of-the-century gentility. But amid all these splendours, nestling in the middle of an ever expanding bosom, would be the two pigeons in their tub. This recurrent, silent reproach became a source of exasperation and despair to my mother, and I have seen her in a state of violent agitation waiting for the visit, hoping against hope that the offending brooch would have been lost.

At last, the welcome news arrived that the, by now, less-young lawyer had gone to settle in Messina where he had acquired a good practice. Mother heaved a sigh of relief and forgot all about him.

Not for long though because, a few days before Christmas 1908, he announced to his dismayed godmother that, in spite of the distance, Mr and Mrs Lawyer would be coming to Palermo between Christmas and New Year expressly to see her. But they never did come, because both they and their three children were killed in the earthquake. Furthermore, the part of the town in which they had lived had become a great mass of gutted debris and the bodies had never been found. It was, of course, a terrible tragedy, but some time afterwards Mother was heard to say, 'In the immense tragedy of this holocaust, there is for me one tiny little glimmer of light . . . I shall never have to see the brooch with the pigeons again.' A callous remark perhaps, but quite human.

Months passed, the winter had gone, it was May, the lilacs were just over but the roses were out and big, juicy strawberries were ripening. We were sitting in the garden being photographed as Grandmamá had a mania for getting professionals to come and snap us in stilted groups. And there we all were, trying to look natural and unconcerned. Decisions were being taken about the closing and opening of the parasols, which was proving difficult as Mamá's was mauve and looked modish opened, but Grandmamá's was black and looked funereal; while these vital points were being discussed, I could hear the distant noise of a tram approaching on the way to the Favorita Chinese Pavilion. As it came near, I heard the brakes squeaking; this was a sure sign that someone was coming to the villa, for otherwise it never stopped. Still, nobody took any notice; the posing went on, Maria Felice with her toes pointing inward and declining to sit more gracefully and the dogs refusing to keep still. Then the gate opened and a lean black speck walked swiftly towards us down the middle of the long pepper tree alley. As it came nearer, it became clear to all, except, I suppose, to Miss Aileen, lost as usual in some green, poetic daydream, that it was the bird of ill-omen. His face was more cadaverous than ever and his gondolas creaked and squeaked as they shuffled along towards us.

My poor mother paled, stood up, waited, the useless mauve

parasol rolling on the gravel. Nearer and nearer he came, his two little pink eyes fixed on that pale face. Now he was rummaging in his cassock and pulling out a small object. He pressed it into Mamá's unwilling clasp and said, lugubriously, 'The ways of God are mysterious, after many months the mortal remains of my beloved sister were finally recognized by this brooch that you gave her and that she cherished so much that she even wore it on her nightgown. I want you to have it in remembrance of her.'

7

AS IN ALL FAMILIES, stories of people and happenings of past ages were told over and over again, until they became so familiar to us that we felt we had actually witnessed these deeds, had actually known these ancient phantoms.

There was the story, for instance, of the Duke who, in a fit of rage, had shot a nun. In those days, the Casa Verdura in Palermo was surrounded by convents and their churches, all active. The din of the bells, all ringing simultaneously at least three times a day, must have been very trying indeed. The nearest was the convent of the Cancelliere, named after the great chancellor of Emperor Frederic II, who had founded it in the early thirteenth century. This historic building, alas totally destroyed during the Second World War, had a massive bell-tower so near the wall of our garden that, from the terrace, you could distinctly see the nun ringing the bell, let alone hear her. It appears that the

old duke in question was particularly exasperated by this special bell and had several times threatened the ringing nun. Finally, one summer evening while he was enjoying the cool of the terrace, his pet hate ascended the bell-tower and started to ring the Angelus with particular vigour. He began to rant and roar as usual. Getting no result whatever, he fetched his gun and yelled at her, 'If you don't stop that infernal noise right away I will shoot you'.

And as the nun, either not hearing or not caring, went on energetically tugging at the rope, he did indeed shoot her.

Personally, I have always taken this story with a pinch of salt. Was he arrested, or was it customary to treat nuns as if they were clay pigeons? Father used to swear to its authenticity, adding that the Duke had gone to spend a few months in the fortress of Messina and the convent had been placated with a handsome present to its church.

We were also regaled with anecdotes concerning a great-great-grandmother, who, completely gaga, lived to a very ripe old age. It appears that she had perfect manners. Her grandchildren, to test them, would bring her a cat or a rooster saying, 'Nonna, here is an old friend of yours come to pay his respects, of course you remember him'. To which the poor old lady answered, with eighteenth-century politeness, 'Yes, of course I know the face, but I am afraid I can't put a name to it'. She had an old canary in a cage near her armchair; she would spend hours whistling to it and listening to it singing back. As the years passed, she became very deaf, but still pretended to hear and to be enraptured by the little bird's warbling. Eventually it died, but she never knew it, because the family, too mean to buy her another one, stuck a lemon to its little perch. The lemon was changed from time to time when it became mildewed. The old lady never noticed the change and went on whistling to it and listening, enraptured, to its phantom song.

Another mythical character, of whom endless anecdotes were told to us, was a certain Marchesa San Giorgio, *née* della Cerda. A real eccentric, she possessed an extremely ugly face, but a very

good figure. Her morals were as straitlaced as her tongue was loose and sharp. She was the perfect wife to a jolly, philandering husband; when he died, she not only wore black for the rest of her life, but never changed the fashion from 1861, the year of his death. Thus, she wore a crinoline to the end of her days in the early nineties. When she was first married, ladies of quality were not supposed to go on foot in the streets and if, perchance, they had to, it was customary for a footman or a maid to walk two or three paces behind, carrying the umbrella and the parcels. The Marchesa San Giorgio, however, defied these conventions and used to take long walks by herself, not only within the walls of the town but also into the countryside. One fine morning, being especially satisfied with herself because she was wearing a new frock and a new pair of booties, she had the feeling that someone was following her. Pulling down the veil of her bonnet she turned her head ever so slightly to take a peek. Of all people, it was her spouse, the Marquis! His stovepipe hat at a rakish angle, twirling his cane and puffing at his cigar, he was actually following her!

Instantly understanding the situation, she strode along, swaying her hips just a little bit, stopping now and then to look in a shop window or pretending to adjust one of her boots and so show some of her ankle, but always starting anew as he came too near. In this manner, she egged him on and on for – what seemed to him – miles and miles. Unlike his better half, he was not a good walker, being more accustomed to falling into one of his club's leather armchairs than indulging in that minor sport that the French call *le footing*. Undaunted, she led him further away through suburbs, orange groves and vegetable gardens, till they reached a narrow road flanked on both sides by high walls and ending in front of an elaborate, tightly-closed portal. The wretched man, now panting painfully, thought that he had at last cornered his prey, that the moment of truth had arrived, as she couldn't possibly go any further. He was catching his breath and was about to proffer some vapid compliment when she swiftly

77

turned around, lifted the veil from her ugly face and stuck out her tongue at him.

This same Marchesa had a garden with a fountain. One day she was sitting on the edge of it feeding the goldfish, when a man, leading a donkey and followed by a dog, happened to pass. She stopped him and addressed him with a smile, 'Tell me something, you are a rural man and surely must know it?'

'At your service, Signora Marchesa.'

'Well, how do you distinguish the sexes of fish?'

'I am afraid I don't know, but if the Signora Marchesa wants to know about donkeys and dogs I can tell her right away.'

'Don't be stupid, I'm not blind and can see donkeys and dogs for myself. I want to know about fish.'

One day, the Marchesa received a visit from some distant relative and her daughter. The voluble relative was telling the Marchesa about her family, boasting about their great expectations. How the blushing, unattractive girl sitting next to her was being courted by a prince – she could not as yet disclose the name, but it was well known to all. How her eldest son was going to marry a rich heiress (a little lacking in blue blood . . . but, confronted with such wealth, one must close an eye). How her younger son was doing so well in the diplomatic service that she wouldn't be surprised if he soon became the youngest ambassador they had ever had! The bored hostess stood it as long as she could, then, with great calm, started to slap her own face, first on one side, then on the other. Her astonished interlocutrix asked the reason for this strange behaviour and received the reply, 'I want to chastise my face, as it's obviously the face of an idiot, because I don't believe one word of what you're telling me, yet it allows you to tell me such a pack of lies'.

The Marchesa's death was as eccentric as her life had been. I don't know what illness had overtaken her, only that she had been bed-ridden for a long time, could scarcely move and was unable to speak at all. Members of the family in great perplexity, hovering on the premises, wondering who would have the

courage to tell her that perhaps it was time for a priest to come and administer the last sacrament to her. The complication was that, although she had been fairly religious, she also happened to be extremely superstitious and possessed the firm conviction that those black cassocks brought bad luck – they were all right in church where they belonged, but woe betide you if you met them abroad! At the sight of one, she would close her hand leaving the index and the little finger extended against the offending object, the age-old Sicilian gesture against the evil eye. It was called *fare le corna*, or making the sign of the horn. Father, then a young man, offered his services, which were gratefully accepted, as the rest of the family were all a bit frightened of the formidable old lady.

He was ushered into her room. There she lay, motionless like an old ivory mummy, in her white finery in her big white bed; only her malicious black eyes darting to and fro gave any sign of life. He sat uneasily by her side, and the following eerie monologue began:

FATHER: Dearest Zia, you know that you are very ill indeed.

SHE: *imperceptible nod of exasperation as if to say* Of course I know it, you ass!

FATHER: But the doctor says that you are a bit better.

SHE: *a little jerk of the head signifying* He is another ass.

FATHER: So we thought that, maybe, to thank God for your coming recovery, you would like to take Holy Communion with us.

SHE: *vigorous assent by rapid staccato batting of her eyelids.*

FATHER: This makes us all very happy. I will immediately go and fetch the priest.

At the mention of this word, her whole body trembled and out shot the first and little fingers of both hands, her eyes rolled in horror and terrible grunts came out of her poor, distorted mouth.

FATHER: But you just conveyed to me that you wanted to take communion.

79

SHE: *in went the fingers, and her head eagerly nodded.*

FATHER: Yet you refuse to see the man who is bringing the Holy Ghost to you.

SHE: *out came the fingers again with more frenzied denials and groans.*

FATHER: What on earth are we to do? You can't, so to speak, have your cake and eat it, or rather, in this case, not have it and eat it.

She looked up at the ceiling while the ghost of a very faint smile suffused her withered lips.

FATHER (*exasperated*): You are impossible, I'd better go and consult the rest of the family.

After many hours of discussion, whilst everyone proposed new schemes, the dilemma was solved with true Sicilian ingenuity. A big screen was found and put up by the bed at a strategic angle. Behind it stood the minister of God unseen by the patient. Inserting the host in a slit at the top of a long bamboo cane, with the aid of skilful directions from the family ('lower down . . . a little to the left . . . no, that's too much . . . a bit too high . . . easy . . . easy . . . open your mouth, Auntie . . . there we are . . . perfect!'), the worthy, if bewildered, padre was able, with acrobatic skill, to perform his duty to the satisfaction of all.

Another mythical creature was a certain Contessa Gallidoro. British-born, married to an Italian, like so many of her compatriots in the same situation, she never bothered to learn even the rudiments of Dante's language. Apparently she dressed in a rather peculiar fashion and had ordered her tailor to make her a kind of redingote. This coat was supposed to have a row of buttons starting from above her ample bosom all the way down the front to her knees. When it was finished, she went to try it on for the last time and was appalled at what she saw. There were too many buttons, far too many. It wouldn't do at all . . . she couldn't possibly wear a thing like that! So she explained to the confused tailor where the error lay.

'I wanted, not *bottone, bottone, bottone,* but *bottone, aspetta un*

momento, bottone, aspetta un momento, bottone, aspetto un momento . . .'
History does not relate what happened to this strange garment
in the end.

This same personage was the proud possessor of a victoria
drawn by a white horse. Now this horse, like many of its kind,
had a tendency to shed its white hair, to her intense indignation.
Using the Italian word *'Pelos'* for the English 'hair', she protested
to the coachman: 'Not possible! *Pelos* here, *pelos* there, *pelos*
everywhere. . . .' It became a household saying. At the sight of
dogs' hair on our clothes or of a little girl with long curls, we
would exclaim, *'Pelos* here, *pelos* there, *pelos* everywhere.'

In the last years of the Bourbons and after, one of the great
beauties of her time was the Princess of Giardinelli. Vicacious,
witty, very religious, she went regularly to her father confessor,
but her Confession was always the same and the shortest ever,
'Father, as usual . . .'

We had many original characters in the family apart from the
trigger-happy old Duke and the Marchesa San Giorgio. My great-
grandfather was also called Fulco, but he was always referred to as
Fulcone because, unlike me, his descendant and namesake, he was
a very big man. He had a very fierce temper, letting himself go in
explosive fits of rage which terrified his diminutive wife. In fact,
the La Cerda family had such a reputation for bad temper and
outbursts of vehement language that a word was coined for such
occurrences – *'cerdiare'* – which meant to lose one's temper.

One summer the whole family was walking through the newly-
inaugurated *Galleria* in Milan and Fulcone was wearing a newly-
pressed, white linen suit. Everyone was feeling in a holiday mood
as they slowly advanced through the throng, admiring the glass
ceiling, the cafés and shops of this famous thoroughfare, when a
little boy, covered in soot, came racing towards the group and
collided into Fulcone, spreading black hands on pristine white
trousers. Turning purple with rage, this formidable man raised
both his fists and was on the point of pulverizing the poor little
chimney sweep, when his terrified wife, expecting the worst,

screamed in pure Sicilian: '*Muriu u picciriddu!*' (The kid is dead!)
This heartfelt cry broke the tension. The irate gentleman laughed
and, to the relief of the rest of the family, the child was able to
escape and reach safety.

The female species of the Cerda family were not renowned for
their pulchritude, but Donna Gertrude, better known as Tutu,
would have won any anti-beauty contest. She was Fulcone's
daughter and so one of my great-aunts. I never knew her, as she
died long before my appearance, but I have seen her photograph.
Imagine a cross between a pug and a pig, several warts, one par-
ticularly large one on the nose, two shoe-button eyes, very near to
each other, and, I was told, reddish hair! She was so ugly that it
never occurred to anyone that she might find a mate. As the times
were over when all unmarried or unmarriagable girls auto-
matically entered a convent, she had become a kind of super-
housekeeper and giver of advice on all matters. But miracles do
happen, or rather nearly happen. In this case, one of her many
distant relatives came to Palermo expressly to tell her dear cousins
that she had found a suitor, called Senzales, for *la cara Tutu*. Initial
stupefaction was followed by utter incredulity. Tutu was asked to
leave the room, while her elders looked into the possibilities of the
match.

'He must be blind,' her father, Fulcone, exclaimed.

To which the lady matchmaker replied, 'Only near-sighted, as
he wears pince-nez, but it doesn't signify, because he's never seen
her.'

'But whatever makes you think that he wants to marry her?'

'Well, I'll explain, he has been named *Prefetto* of Messina. [In
every large town in newly-unified Italy, a 'prefect' represented the
royal government in Rome.] His name is Senzales, he comes from
Apulia and he wants to marry into the nobility.'

Family chorus: 'He couldn't find any damsel better born!'

'He's neither handsome nor young, but then neither is she.
When he asked my advice, I instantly thought of our darling, who
has all the requisites except prettiness and money to make a perfect

Prefetessa. He's not marrying for love and is moderately well off with a grand house provided by the Government. Quite naturally though, he would like at least to have a glimpse of his future wife. So as not to cause embarrassment and thinking that our dear Tutu stood a better chance if seen at a distance, I suggested that next Thursday he should take himself to the opera [the Opera House then was at the Teatro Caroline rebaptized Bellini 1860] here in Palermo and look up at her in box nine. Isn't that your number? Then he will let me have his impressions later.'

The family marvelled at the sagacity and prudence of their Machiavellian relation and sent for Tutu to tell her of the good fortune that had befallen her.

Poor bewildered Tutu! 'You see how right you were to wait' . . . 'Messina is such a lovely town' . . 'So near the continent' . . All this went to the poor old maid's ugly head, with the result that she completely lost it.

She spent the few days prior to the fateful Thursday evening supervising the seamstress who was busy adding some family lace and cerise velvet ribbon to her only evening gown. When the great day finally arrived, the best coiffeur in town – Il Signor Pitini – was summoned to curl her tresses like a sacrificial lamb, pluck the hairs from her warts and powder all. Her married sister, Giovannina, lent her some diamonds, an ancient fan ('use it gently, it is very fragile and very old'), kid gloves (still reeking of benzine that had been used to clean them), mother-of-pearl opera glasses, and she was ready.

Alas, history doesn't record what opera was being performed that night, but I like to imagine that it was *Ione* by Petrella, based on *The Last Days of Pompeii*, and now totally forgotten, for in the last act Vesuvius obligingly erupts with great gusto, followed by a thundering funeral march.

It was obviously a disconcerting evening for the occupants of box number nine. As they came in, many eyebrows in the surrounding boxes must have been raised at the sight of poor, well-known Tutu, all done up like a wedding cake. It must have been

difficult for poor Tutu to look gracefully nonchalant, able to use her fan but not daring to look through her opera glasses at the brilliant audience, yet knowing that, in some corner of the house, someone was using that same instrument on her, dissecting her charms. Her mother and her sister kept nudging each other every time their piercing eyes thought that they had discovered some man adjusting his opera glasses in their direction: but they were never absolutely certain that anyone had actually done so. Eventually the performance came to an end. The curtain fell, bows were taken and the applause petered out. The three ladies were joined by the male contingent of the family, who had watched the performance from the Bellini Club's box, and all went home to wait and hope.

The home they went to was the Palazzo Cerda on the extension of the Via Maquada outside the walls. Alas, the house has gone now and has been replaced by a hideous building comprising a cinema, a bar and God knows what. It was, I believe, at the time of Tutu, a low, classical building, as all the houses in this new street had to be of the same height. I can imagine what it looked like because it faced the Palazzo Villarosa and was more or less of the same proportions. The decorations were in the style of the first Empire and it had a big garden in the back. Unlike Via Monte-vergine, it was probably full of light and space, more like a country villa than a town palace: it was in fact on the corner of a square known as the fourth *canti di campagne* (country) as opposed to the fourth *canti di citte* in the centre of the city. As I said, all is sadly changed and, in place of noble façades and spacious gardens, one sees a cement skyscraper in the middle of a cement plaza surrounded by cement porticoes and the only vestige of the past is a side street still called Via della Cerda.

But to return to Tutu and her lost illusion: Senzales' answer arrived a couple of days later in the form of a telegram from Messina and said simply 'Senzales arriving around six Thursday will advise later'. As was the custom, a great reception was arranged, the red carpet was rolled out, potted palms hired and all

the relations to the fourth and fifth degree invited. While these preparations were going on, early in the morning of the fatal Thursday, a second telegram arrived, 'Senzales will come at six-thirty'.

As the hour approached, the rooms in the big house began to fill with over-dressed ladies of every age and dimension, bored men, stove-pipe hats in hand, and a few noisy children. Tutu, radiant, in a cream-coloured dress, was in a state of agitation bordering on hysteria. All the women kissed her and told her what a lucky girl she was. More and more people arrived, trays of sorbets and biscuits were handed round whilst the champagne was kept for later. Time passed; it grew hotter and hotter. Half-past six; a quarter to seven; and no Senzales. Nervous tension increased, infiltrating through the groups of fanning ladies . . . seven o'clock . . . still nothing . . . 'Really, what manners' . . . 'I suppose these are the kind of people we will have to put up with from now on' . . . 'If this is the new Italy!' Papa Fulcone, so as not to explode in public, had retired to his room, trying to calm himself with a cigar. The hands crept round, it was now nearly half-past seven . . . Tutu's smile had become an heroic grimace . . . and still nothing.

Then, like a harbinger of ill-omen, a footman appeared bearing a paper looking suspiciously like a telegram on a silver salver. He made his way through the silenced crowd to the already distraught lady of the house. With trembling fingers she took the paper, which indeed was a telegram; she slowly opened it. It simply said, 'Sorry, forgot the "not".' In other words, 'Senzales will not come . . .'

Thus ended the only chance Tutu ever had of getting married and having a family of her own. The years passed in monotonous similarity and it looked as if she would never know the ecstasy of a love affair. But Cupid is ever vigilant and Tutu, in spite of her looks and advancing age, eventually found herself some kind of a over. His name was Don Salvaturi and he was *il Mastro d'Acqua*, the Master of the Waters.

All important households in those days possessed this very useful personage. His position was not quite as grand as his name suggests: he was, in fact, a kind of super handyman-cum-plumber and also a carpenter, locksmith or painter; whatever was needed. The Master of the Waters in the Palazzo Cerda would always be found in the *amminstrazione* (administration), waiting for orders. I have to now, I'm afraid, open one more parenthesis and explain that in every house of aristocratic standing, no matter how rich or ex-rich, two or three rooms full of dusty account books and papers would be called the administration. Here, on week-days, one or two old men would come and scribble, God knows what, in an old ledger. I remember vividly the one in the Palazzo Niscemi in town, in which two very old brothers reigned. The hands of the least decrepit fascinated me, because his little fingernails were at least an inch long – to show that he used a pen and not a plough.

But back to Tutu and her Master of the Waters. He was nick-named Toto, but as that sounded too familiar and too similar to Tutu, she called him Don Salvaturi instead. At every pretext she could think of, she climbed to the *amminstrazione* in search of the object of her affection. In all honesty, I don't know how far this romance did go, but, according to Father, as they could not go on meeting up there, with people coming and going, and as Don Salvaturi certainly could not come up to her room via the servants' stairs because the servants would gossip (the main staircase being, of course, quite out of the question), a little spiral staircase was built connecting her love nest with a back street. This satisfied all concerned.

By the way, talking of secret stairs, a dear aunt of mine of irreproachable morals, the Zia Beatrice, showing a little door inside the alcove of her stately bedroom at the Palazzo Niscemi that was supposed to lead to a secret passage, once said with a sigh, 'This is the lover's door, alas it has not been used since the eighteenth century'!

Father used to say that when he and his brother asked Salvaturi,

1 Young Fulco in serious mood

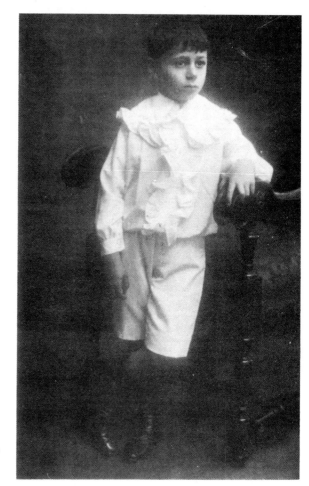

2 My sister, Maria Felice, and I loved animals and were rarely photographed without some quadruped

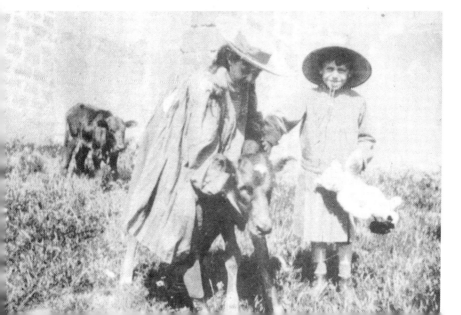

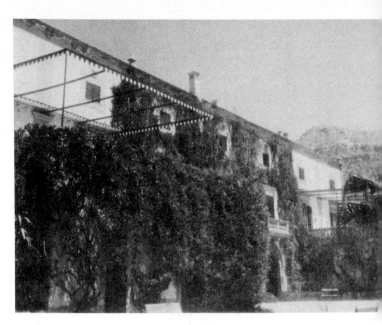

3 Villa Niscemi today, still abundant with bougainvillaea

4 The garden of the Villa Niscemi where we spent so many happy hours. On the left is the gate through which Moffo the camel entered; in the distance Monte Pellegrino

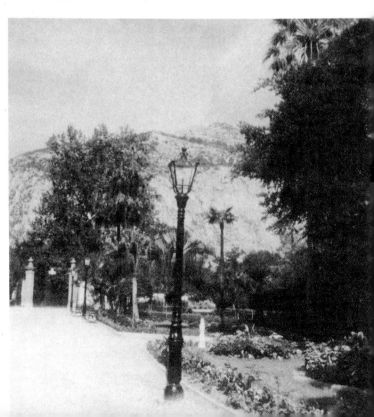

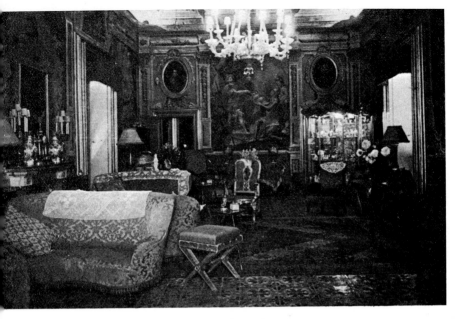

5 The frescoed drawing-room of the Villa Niscemi

6 The oversized Gnu Antonio, head coachman at the Villa Niscemi, amused us by harnessing my tiny mule to the dog cart

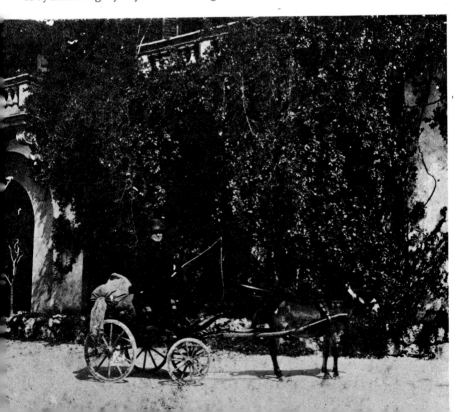

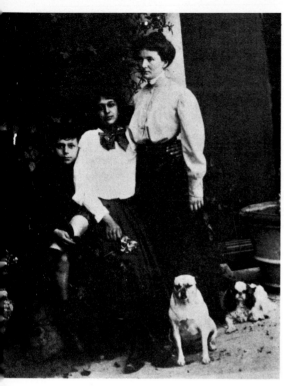

7 Fulco, Maria Felice and governess Miss Aileen with our two beloved dogs, Musetta and Lady

8 On the beach at Mondello: Fulco (left), Maria Felice (fourth from left) and friends, watched over by Mamá

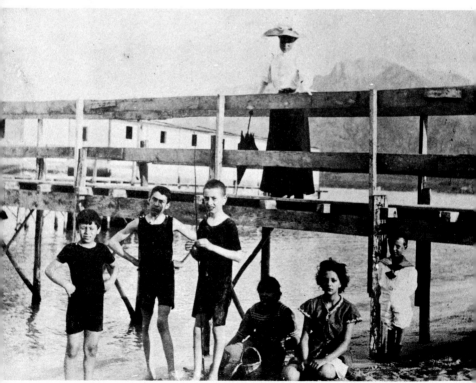

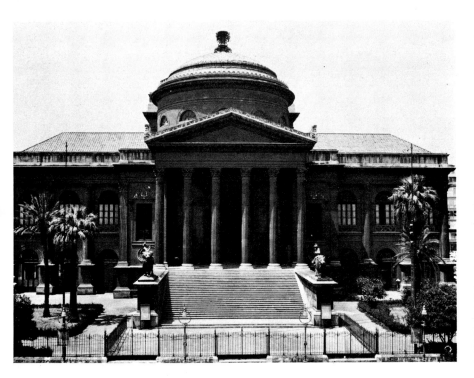

9 The monumental proportions of the Opera House in Palermo always impressed me as a child

10 The Bay of Palermo and Monte Pellegrino with the great white city at its feet

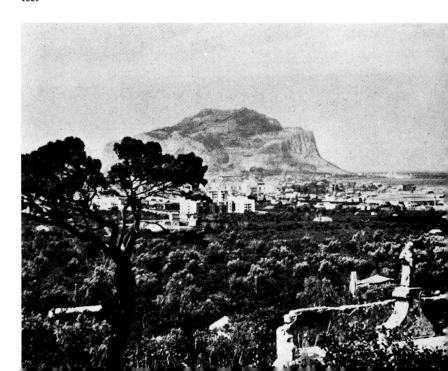

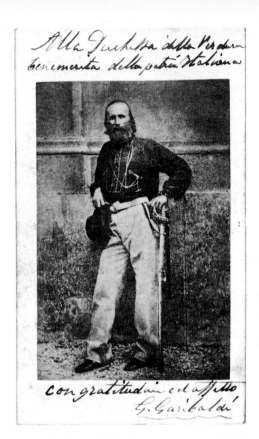

11 Garibaldi gave this signed photograph of himself to my great-grandmother

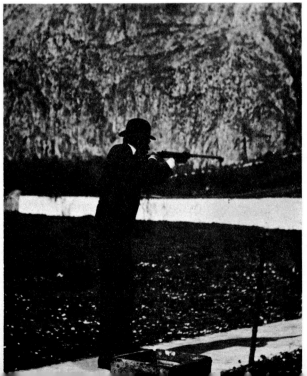

12 My father clay pigeon shooting in La Favorita, the royal park

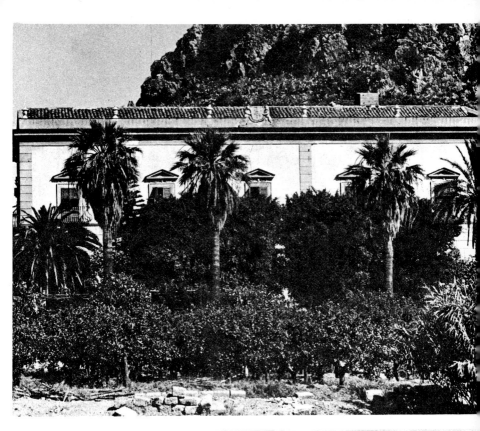

13 *Above* Villa Serradifalco at Bagheria, Father's second home, was another place we loved. La Montagnola looms behind

14 Fulco photographed with Abu-ba-Ker, the Somali chieftain's son who came to stay at the Villa Serradifalco

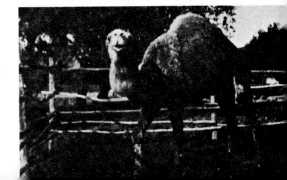

15 Moffo the camel who caused such excitement with his arrival at the Villa Niscemi

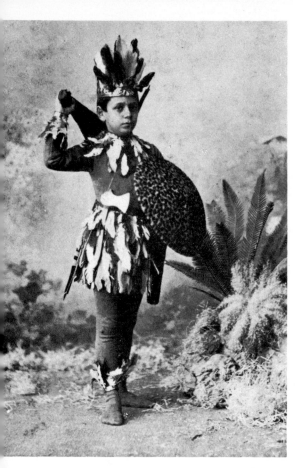

16 A reluctant savage at a fancy dress party

17 At the Villa d'Este. Maria Felice, Fulco and Mamá are seated at the table; Grandmamá on the left. Also in the picture is Moffo, the gentleman after whom we irreverently named the camel

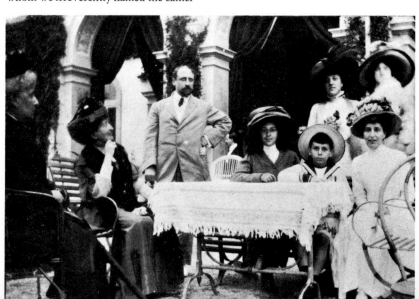

'But, how can you?' Salvaturi would blushingly reply, 'I think of her ancestors'. However, I didn't blindly believe all Father told me.

Tutu's death was dramatic. She developed an illness which kept her in bed on a strict, light diet; this caused her much distress as she was, what is known in France, as a *bonne fourchette* and adored spaghetti and seafood. At that time, Count Mazzarino had recently married a Neapolitan young lady, Luisa Ruffo, who was to become the mother of our great friends. Luisa had never been to Sicily and was not familiar with the islanders' strange ways. She was introduced to all Palermitan society, and so came to see my great-grandparents and the bedridden Tutu. They somehow sympathized and a kind of friendship was born. The young Countess went to see the ailing woman several times, and one day the invalid asked if she could share a little secret with her. 'Of course,' was the answer. 'Well, my dear, for some time I've had a craving for a certain dish, but they won't let me have it. Now, they tell me that you have a wonderful chef, could you have it made and bring it to me in secret? You could come up my private staircase, my maid will help you, nobody would be the wiser and you will have made an old woman very happy.'

The dish in question was a Sicilian speciality called *pasta con le sarde*, a baked concoction of macaroni, fresh sardines, pimento, wild fennel, saffron and sultanas, all stuffed with as many herbs as possible. Not exactly suitable for an invalid on a strict diet.

The scheme was carried out successfully, in great secrecy. Thus it came to pass that the fatal dish, which was to be the last, came up the little spiral staircase built for a far different purpose and the good Tutu was no more.

To continue with my galaxy of sacred monsters . . . there was also the sister of the late lamented Tutu, Giovannina, who had married a Count Trigona and was the grandmother of the Oddo children about whom I have already spoken. There is little to relate about her as she was a perfect wife, excellent mother to two daughters and had, I presume, a quiet and normal life. Her claim

to fame was of an anatomical kind. Poor Giovannina's breasts were so over-developed that the only way she could achieve even a precarious balance was by tying them together and stuffing part of them in a corset; otherwise it was extremely difficult for her to move around without risk of falling forward, dragged down by the sheer weight of her appendages.

One night Giovannina was awakened by the smell of smoke and, to her horror, saw that the curtains of her bed were on fire. The good lady did not lose her head. She pulled the bell as hard as she could and struggled out of bed. Knowing that she would never have time to put on her corset, she staggered as far as the chimneypiece and was able to place her burdensome appendages up on it. Precariously poised, she began to shout orders: 'Wake the children . . . Call the fire brigade . . . Bring all the buckets you can find . . . Don't panic . . . Girls, don't be afraid . . . we have mastered it!'

Incidentally, her husband, of whom I knew next to nothing, must have been a jolly individual – his grandchildren showed me a photograph of him in a top hat sitting on a pot!

Although we heard these stories over and over, most of the people who figured in them were not known to me personally or had long since died. However, there were plenty of living, elderly relations who seemed just as bizarre and upon whom I gazed with amazement: their activities were rapidly becoming the family myths of the future in front of my eyes.

As well as the top-heavy Giovannina, there was Tutu's brother, Alessio. When I knew him, he was blind, very ugly, very witty, his voice a growl, his remarks savage bites. Without a bean, he lived in a basement with a valet-cook who had one eye and one leg, which led him to say, 'In our *ménage*, we have one eye and three legs.' He had had two wives, a Scottish wife in Florence and a Dutch one somewhere else. The former, *née* Matty Campbell, I remember well. She was vivacious and *simpatica*, dabbled in painting and spoke a fluent hybrid Scotch-Sicilian. The latter I never met.

Amongst the ghosts that haunted our world, none was more familiar than dear old Monte. She was an elderly duchess who happened to be related to both my paternal and maternal families. Her real name was Montalbo, a grand-sounding name indeed, but there was absolutely nothing ducal about this amiable, rustic, little old lady. A lugubrious-looking, one-horse carriage, rented from a firm answering to the name of Pescemorto (alias 'Deadfish') would clip-clop along and out of it would slowly emerge the figure of an amiable frog dressed by Beatrix Potter, but in dark colours. Her language was of the purest Palermitan stock, cosy and intimate, just as if she was imparting some very important secret. Her world pivoted around her eleven grandchildren and her twenty-odd great-grandchildren. None of their colds, illnesses, christenings and marriages was spared us. She always wore the same little bonnet. The crown of it was made of inter-twined dark red velvet ribbons wrapped around with some kind of black velvet and jet and, hanging from the sides, two long velvet streamers that she tied under her chin. This headgear had a hypnotic power and, as she always left it in the hall along with her gloves, I had every opportunity to examine it at my ease. It had obviously seen better days. Poor old bonnet – one special afternoon nearly proved to be its last. A friend, Dino Montallegro, was playing with us, when he spotted it on a chair, picked it up by the ribbons and started to rotate it over his head and then throw it. A very lively game of football ensued. Of course, as the saying goes, they don't make them like that any more; this particular bonnet survived its very rough treatment and continued to adorn the head of deal old Monte for many more years. Funnily enough, this same Dino later married a very pretty girl, Clotilde, who was Monte's granddaughter.

I have always been fascinated by links with the past, and the old lady could boast of an unbeatable one. As a child under the Bourbons, she had been educated (so to speak) at the *Istituto Carolino*. The French teacher who was trying to introduce her, in vain, to the mystery of the Gallic language, had actually seen

Marie Antoinette, in the tumbrel, on her way to the scaffold as a young girl in Paris. Incidentally, this school was called Carolina after Marie Antoinette's sister.

In a dark palace in the gloomy Via Butera, just behind the Marina, lived a formidable lady who could also boast an impressive link with the French Revolution. She was the Princess Torremuzza, *née* La Tremoille, and was exceedingly conscious of this noble ancestry. Grandmamá was fond of her, went to see her often, and sometimes took one of us along. As in the family there was a propensity to bestow nicknames, she was known as La Chère Toré. With the ferocious aspect of a large parrot, she was nevertheless affable, amicable and *très grande dame*. While the ladies sipped their coffee and nibbled at their dusty-looking biscuits, I was able to roam undisturbed in the semi-obscurity of high, vaulted rooms, especially fascinated by a certain monumental piece of furniture. Imagine four sofas, in the shape of four Ts, joined together at their bases by a tall *capitonné* mound, surmounted by a huge potted palm tree. This whole indoor 'folly' was covered in yellow damask. The four Ts were in proud remembrance of her origins and marriage. They stood for Tremoille, Tarente, Thouar and Torremuzza. (One shudders at the thought of her having been called instead Wellington, Walpole, Wallenstein and Washington!) Every year when we came back from Paris we presented her with a little *bonbonnière* full of earth gathered in the gardens of the Tuileries. It was a very sentimental little ceremony that never failed to produce a few tears, a couple of sighs and a mopping-up handkerchief.

La Chère Toré's link with the French Revolution was a tragic one. Her father had been married when still a boy. His baby wife had been guillotined in 1794, and he was only saved by Thermidor and the fall of Robespierre. He did not marry again until he was sixty and then he had two daughters, the eldest being our friend Toré. When we used to go and see her she must have been around eighty. Therefore, as a little boy, I had kissed the hand of a lady whose step-mother had gone to the scaffold in 1794.

90

The famous centenarian, Count Greppi, whom I vividly remember, lived in Rome. A dessicated creature with tiny hands and feet, he took small, shuffling steps and looked as if he had been wound up. As a young *attaché* at the Court of the Duchy of Parma, he had danced with Napoleon's wife, Marie Louise.

Nowadays Garibaldi seems a semi-mythical hero, yet in my childhood days he kept popping up in conversation; the comments were not always favourable because of his noted anti-clericalism. My mother's father, Corrado Niscemi, had been a Garibaldino and worn the famous Red Shirt, and had previously been imprisoned by the Bourbons. On my father's side, there was my great-grandfather, known as 'il Duca'. I don't remember him – I was only four when he died – but his shadow loomed large in the house on Via Montevergine. A great patriot, he had, because of his liberal views, spent many of his younger years in exile in Malta and later in Florence, where the Granducal regime was much more tolerant than the one in Naples. His own father, on the contrary, was for a long time Governor of the Basilicata region in southern Italy and after that he was nominated Praetor of the city of Palermo, a charge he held for several terms. When he died in 1859, his son was not only allowed to come back from exile to his native island but was appointed, with typical Bourbon obtuseness, Praetor himself by the new King Franceschiello (Francis II). The Praetor was a kind of Lord Mayor, but with far greater powers. Less than a year later, Garibaldi and his thousand landed at Marsala, won the Battle of Calatafimi and entered Palermo. The Praetor, who had conspired for the unity of Italy for most of his life, was only too willing to give him the keys of the city. (Alexandre Dumas *père* gives a none-too-flattering description of him in *Les Milles*.)

Il Duca was a man of many parts, Senator of the Realm, several times Lord Mayor, great art collector and critic. He was considered a great authority when artistic disputes arose. This last attribute I take with the classic pinch of salt when I consider the innumerable mediocre pictures I found in the house when my turn came. (But then the best ones had long ago been sold.) At

91

any rate, he was considered a kind of bearded sage with a large variety of interests, fossils, shells, stamps, Murano glass and wines. Of course I heard a lot about him from his descendants, but never a direct quote of anything he had said. His own daughter, the Baroness Pajno, whom I was dragged to visit quite often, spoke at length of *il babbo* (she had been educated in Tuscany) with reverence, but never with affection. One thing is certain, he must have been devoid of any sense of humour.

I still possess a photograph of Garibaldi with his great sword. A severe look on his leonine features, he is holding in his right hand a peculiar South American round hat. The dedication reads: '*Alle Duchessa della Verdura benemerita della patria Italiana con gratitudina e affetto. G. Garibaldi.*' But this *affetto* nevertheless had its thorny side because, if they were all patriotic Italians with liberal leanings, they also were practising Catholics and, in some cases, ardent ones. In the eyes of the Roman Catholic Church the mere name of Garibaldi was anathema. He was excommunicated, had fought against the Pontifical troops, and it was said that his *éminence grise* was an unfrocked friar. It was therefore rather tricky to conciliate both sides. In 1882, a few months before his death, Garibaldi came to Palermo for the sixth centenary of the Sicilian Vespers. At some kind of reception, Mother, then a little girl of twelve, as daughter of a Garibaldino, was to present him with a bouquet of flowers. In the family, particularly the distaff side, it was thought wicked to expose a child, who had just made her first communion, to even a fleeting contact with an atheist and *mangiapreti* (priest eater), so, in order to counteract the evil fluids that might emanate from him, they stuffed in her pocket a rosary, to which a maid, to make things better, had added a little coral horn.

Mamá had been chosen to present the bouquet because she was twelve, which seemed to be the right age, but her sister, Zia Lilly, would probably have been a more suitable choice as she was made of sterner material. (She was the mother of that dreadful cousin whom Maria Felice teased so much and so often.) Aggressive and

perenially ready to take offence, nobody could have ever guessed that she and Mamá were sisters. Zia Lilly was the younger of the two girls, and never allowed this fact to be overlooked. A compulsive talker, she prattled along in pure Sicilian lingo in the most absurd manner, jumping from one subject to the other but always sure of herself, to the utter exasperation of her listeners. A slave to hatred and enthusiasm, it was sometimes difficult to distinguish her snarl from her smile. Vehement in all things, she managed to make everyone around her, including her daughter, highly uncomfortable. Her first husband had, not surprisingly, jumped out of a window; she had then remarried and produced two very indifferent little boys who were totally ignored by us. This second husband was a young artillery officer. He looked like a chocolate soldier and was known to the family, headed by his mother-in-law, as *il pupo*, the puppet.

Aunt Lilly (pronounced with the accent on the 'y') was a lady addicted to fads which were dropped just as suddenly as they had been picked up. The worst time was when she turned to theosophy. Grandmamá, who had also dabbled with this philosophy, was so irritated by her daughter's emulation that, as an act of abjuration, she burned a very short letter she had once received from Annie Besant, the famous theosophist. Anyhow, we all had to listen to stories of reincarnation, of lions having one soul for every four of them, while sheep have one for every hundred, and so forth. It all ended in the most farcical way. In some theosophical magazine, she had read an advertisement from a French lady residing in Florence who badly wanted to meet someone whose soul, in one of its transmigrations, had lived in ancient Egypt. Of course it instantly all came back to my aunt! She had lived by the Nile, in ancient days! Some time later, having to pass through Florence, she wrote to this French lady saying that she would be delighted to make her acquaintance and compare pharaonic souvenirs. An appointment was arranged and, in an atmosphere charged with electricity, the two met. It turned out to be the shortest visit either had ever paid.

This is more or less the conversation:

FRENCH LADY (*standing haughtily and not offering a chair*): Madame, the last time I saw you near the lighthouse in Alexandria, you were a slave.

AUNT: Excuse me, Madame, you are mistaken, *you* were the slave! I can see you still bent in two under the terrible weight of carpets you were carrying on your poor back. (*Slight pause.*) I was the High Priest of Isis on my way to the library.

FRENCH LADY (*whose temper is rising*): How dare you speak to me like that! I was a royal princess passing on my golden litter borne by my Nubians.

AUNT (*with scorn*): If you were a princess you could only have been Aida, because I had never seen such a dark princess before, making your Nubians appear positively ashen. As far as I'm concerned, I can prove that I was the High Priest, because I died devoured by a lion and to this very day, whenever I am in the presence of one of those royal animals, I instantly feel a very strong pain in the pit of my stomach, as it was just there that I received the first clawing.

FRENCH LADY (*inflamed*): In that case I would suggest that you go back to Rome and have some lion finish the job in the Coliseum.

AUNT (*in cold rage*): I was just going to return the compliment advising you to go back to Egypt to get mummified, but, looking at you, I can discern that this process has already been achieved . . .

And out she sailed, banging the door behind her.

This is how she told the story, but, not knowing the French lady's side of it, I wonder which one actually got the last word?

8

THE DAYS OF MY CHILDHOOD followed one another at an uneven speed: some dawdled dully along full of dreary lessons, some raced by filled with excitement, others were full of anticipation of delights to come: the delights themselves centred round the feast days, holy days and saints' days of the church's calendar. The most important of these in Sicilian eyes was undoubtedly 2 November, All Souls' Day, but to me Christmas seemed the best.

In those faraway days in Sicily, a real Christmas tree was as rare as an angel's visit and was only seen in the few households where there were English or German governesses and, of course, in those houses belonging to the members of the British colony, the Whitakers, the Gardeners, the Smiths etc; for Sicilians, like Italians, Christmas was traditionally celebrated not with a tree but with a crèche, a tradition that went back to St Francis of Assisi.

Moreover, fir trees were very hard to obtain as they only grew in the Madonie mountain range and someone had to go up there to cut one down, which was such a complicated and expensive operation that sometimes we had to make the best out of branches of pine trees nailed together on a trunk by the gardeners. The decorations had been bought in Paris and every year we added some more.

On Christmas Eve we always went to midnight mass at our neighbours, the Gebbierossas', where there was a private chapel. How hard it was to keep awake that long but how proud we were to be like the grown-ups. Before mass we had to exchange presents with the Gebbierossas and pretend to admire their tree and the crèche, although we always thought that our own was much grander. After mass, like two somnambulists we would be given a cup of hot broth and a thimbleful of Marsala. Next morning we went to another two masses, this time in the pretty round chapel of La Favorita. Back home to an enormous Siculo-British lunch starting with spaghetti and ending with mince pies! In the evening we had the plum pudding topped by any old sprig, as holly doesn't grow in Sicily, and plastic had not then, thank God, been invented. The next few days were spent going from one Christmas party to another – at the Trabias', the Whitakers', the Mazzarinos' or the Florios', exchanging presents. Our own tree was always the last one.

My presents usually included what were known in Paris as *panoplies*, and which came from the famous toy shop in the rue du Faubourg St Honoré, *Le Nain Bleu*. They were big cardboard shields to which were attached different parts of a fancy dress: cowboy, zouave, Foreign Legion and so on. Once I received an Indian outfit complete with clubs, a very fancy Indian more reminiscent of Papageno than the south-west. Every year I also got the albums of Buster Brown, Little Nemo and Happy Hooligan, the first being by far my favourite.

Both at Christmas and at Easter time, the nuns from all the different convents sent us extraordinary sweetmeats which they

had made themselves. The *fastucata*, a pistachio pie as heavy as lead; the *crocchiola*, a scalloped shell made of pistachio marzipan stuffed with *ricotta* and candied fruit, and of course the famous *minne di virgine*, alias breasts of virgins – daintly little mounds of almond paste, *grandeur nature*, filled with some kind of fruity stuffing, baked in a way that made the tips turn browner. These sweets arrived in trays lined with multi-coloured paper and covered with tinsel and little sugar balls dipped in silver and gold.

This was the season when the *ciarameddari* descended from the mountains playing on their *ciaramedda* or bagpipes. We went in search of them in all the little back streets of the old town, straining our ears for that plaintive, ancient sound. They were a strange sight in baggy trousers, sheepskin spencers, leather leggings, black felt capes hanging from one shoulder and sort of oblong tam-o'-shanters on their hirsute heads . . . and all the while their bagpipes creating nostalgic sounds. No disparaging comparison with Scotland or Ireland on the part of Miss Aileen could spoil our rapture.

These singular creatures evoked high mountains, snow, carols, icicles, snowballs and sleighs, all the trappings of northern Christmases that I only knew about from books or Christmas greeting cards. Of course I had seen snow from a distance as the semi-circle of mountains that surrounds Palermo is covered with snow during most of the winter, but I had never actually seen it come down, I had never touched it or made snowballs. I had never experienced the wonder of waking up one morning to a silent stillness and looking out of the window to discover a white, padded world. I felt a yearning for this wonder and, if it is possible to have a nostalgia for something one has never had, then this was it.

It was the same with the swallows! Of course I knew what a swallow was like and had seen lots of them, but they just passed early in the spring, stayed a couple of days and then flew north. In October, when they returned on their way to Africa, we were

97

usually still abroad and missed them. It seemed to me unjust that they wouldn't stop in Sicily, but went on to Rome where the climate was not so very different. I felt slighted and hurt to be overlooked by these harbingers of spring.

Both these childhood desires were eventually satisfied. One winter the snow actually did fall and we could scrape enough of it together to make snowballs and pelt Miss Aileen with them. We were even photographed against a background of snowy palmettos. Everyone became very excited about this snowfall and a procession went up Mount Pellegrino to the shrine of St Rosalie as the snow had remained on it for more than twenty-four hours, an occurrence that hadn't happened in centuries and was supposed to be a good omen.

As for the swallows, this longing ended in tears. One evening we found a dead one on the window sill of the bathroom.

If, in many countries, it was Santa Claus who brought presents at Christmas, in Italy, in days gone by, it was an old hag called *La Befana* who arrived on a broomstick on Twelfth Night with presents for the good little boys and girls and ashes and coal for the naughty ones. But in Sicily, where everything was different from anywhere else, it was neither of these two personages, and on neither of these two nights. The little ones received their toys and games on the second of November and they were left at the foot of the beds by the dead. The Church discouraged this belief as it was apparently of pagan derivation and it must have, by now, completely vanished. I, being one hundred per cent Sicilian of Spanish descent, didn't find this belief at all macabre but thought rather that the notion that my dead grandparents or perhaps my dead brother were watching over me, their living relation, and had brought me presents had a melancholic, poetic charm. Sicily is an island of dramatic contrasts, barren mountains and crags, deep gullies, lunar landscapes as dry as bones in the sun, and orange and lemon groves, refreshing valleys, reposeful beaches and silvery olive trees. It is a tragic island of darkness and dazzling light with no half-tones, where Death is omnipresent.

The second of November, All Souls' Day, was, and still is I suppose, one of the great feast days of the year. Most Sicilian families of the lower classes climbed into carts carrying a few chairs, enlarged photographs of the dead, candles, food and newspapers and proceeded to the cemetery to spend the whole day with their loved ones. Having propped up the photographs with candles to form a kind of altar and spread a newspaper on the grave to let the deceased read the latest news, they would then proceed to have their picnic and to enjoy the outing: sometimes they even called one of the itinerant fiddlers over to play them some vaguely religious ditty.

Palermo was a city of cemeteries and churchyards, each one class-orientated. By far the most aristocratic ones were those attached to the churches of St Orsola and St Maria di Gesú. Every 2 November we would visit our family burial place which was a small chapel in the grounds of St Orsola. As a child I always considered St Orsola as 'my church'. It was a magnificent edifice built by the English Archbishop Walter of the Mill in 1173. He had been sent over by Henry II to accompany his daughter, Joanna, when she came as a bride to King William the Good of Sicily. Walter of the Mill stayed on in Sicily where they called him Gualtiero Offamilio and built the great Cathedral of Palermo as well as our church. But St Orsola was unlike any other of the same period in Sicily, for it had no mosaics nor oriental splendour, instead it was severe and nordic. The round pillars, naked of all ornament, the pointed arches and bare stone walls have a stark, gaunt grandeur in poignant contrast with the exuberant vegetation which surrounds it.

Our own private chapel was a pseudo-Gothic affair with only one empty place left waiting for me, the last of the family. To be quite correct, it is not completely empty because, tucked in a corner, are the tiny remains of my brother, the shortlived Garibaldi. I used to ask my mother why on earth, or rather under it, the poor little baby had not been put in her own or Father's cubicle instead of in mine, for I had not even been born at the

time. The answer was typical and also logical: 'Because, if he had lived, you would never have been born and he would be in his rightful place as the last heir.' St Orsola, formerly Santo Spirito, is a peaceful place full of flowers and birds, where I am sure I will one day feel at home surrounded by relations and friends.

But St Orsola has not always been a place of silence and serenity; once it was the scene of one of the most important and bloody deeds in the history, not only of Sicily, but of the whole of Italy, now known in history books as the Sicilian Vespers.

After the death of Emperor Frederic II, the Pope offered Sicily to Charles of Anjou. The Sicilians, still dreaming of past glories, hated the new ruler and considered the Angevins to be usurpers. They were only waiting for an excuse to revolt. It came on Easter Monday, 1282. As no marriages were allowed during Lent, several people had chosen this first day after Lent for their wedding day. As the last couple was coming out of the church, a Frenchman stepped forward and chucked the passing bride under the chin: the groom instantly drew his dagger and stabbed him. At that very moment, the first stroke of the vesper bell sounded and the massacre of all the French began. The tocsin rang from belfry to belfry giving the alarm to the citizens of Palermo who, as Dante says, started the hunt to the cry of 'Kill, kill . . .' When dawn broke, no living Frenchman was left.

This is how the story was told to me and a great cross in front of the church was said to be the spot where the massacre began and where all the French were buried. But I don't think that the revolt was really quite as spontaneous as my enthusiastic family would have liked to believe. It was primarily instigated by Giovanni da Procida, assisted by the House of Aragon, in whose veins ran Hauteville blood and who, in consequence, claimed the Kingdom of Sicily for themselves.

I was also told that, on that fatal night, to make sure that the quarry was the right one, any wretched creature caught was made to read the written word '*ciceri*' (which is a kind of bean which the French call *pois Chiche*). If he pronounced it *chicheri*, all was

well, but if he said *siseri* he was instantly despatched. I wanted to introduce this as a game, but failed because I didn't know any French children.

But to return for a moment to cemeteries, I often visited the other aristocratic one at Santa Maria di Gesu for, from it, you had the finest of the many fine views over Palermo, the Conca d'Oro and the sea. The building itself was a fine fifteenth-century Franciscan monastery with a charming fountain and some Renaissance tombs. The interior was anything but funereal. Full of light, the sun came streaming in from the large windows over the arches: in front of each one was a big cage full of canaries that sang out their happy little souls during the services. This custom was frowned upon by long-nosed bigots, but at home we approved of it as it was in keeping with St Francis's love of little birds.

The biggest cemetery of all was under Monte Pellegrino by the the sea, not at all fashionable – it was called I Rotoli. Families which did not spring from the top drawer were often described as, 'You know, the kind of people who are buried at Rotoli'. In fact, no one liked to be seen in it alive, let alone dead. I myself never went there but my father did take me once to the Convent of the Capuchin Fathers, not to see the graveyard, because that was an intimate plot of land surrounded by cypress trees, but to visit the long, subterranean galleries that lay underneath. It was an unforgetably horrible experience. We went down a long flight of steps into a kind of hell from which irradiated interminable corridors crowded with mummified bodies all dressed according to their lifetime status. Monks by the hundred hung from the walls, abbots and bishops lay in open coffins. Laymen were in further corridors, all dressed in the best clothes, white ties and tails, judges' robes, uniforms. Women were in evening dress with fans or handkerchiefs in their hands and flowers in their hair, widows in black and the children, the horrific children in white satin with enamel eyes stuck into black parchment faces. This barbaric custom of embalming the dead was only stopped

less than a century ago. When I saw them, many had daguerreo-types and photographs beside them. All was lit by hanging lanterns that swayed to and fro giving the impression that these poor people were gently moving in ghostly shadow. As I came out into the sun and felt myself to be alive, I resolved to put what I had seen out of my mind and never to return.

November 2 was indeed a great day in Sicily. A toy fair was held in the big square under the Royal Palace Gardens, a fair for the dead. There, my father and I would meet our three ladies back from their visit to the family tomb and we would all buy a great deal of hideous rustic nonsenses and I would ask for a puppet. Simply-carved wooden puppets hung from every stall and all along the streets I could hear the cry, '*Chi ti puraru i morti?*' (What did the dead bring you?) and back would come the answer, '*Un Pupu cu l'anchi torti*' (A puppet with crooked hips).

Death is at home in Sicily. Sicilians are used to her presence. The everlasting mournings, the continual references to dead people as if they were still alive, all familiarized me with the idea of death from earliest childhood. Death was a most natural event, something that happened regularly like night following day. When the father or mother of a family died, the *porte cochère* had to remain closed for the rest of the year as a permanent reminder to all passing by or entering the house.

One old Palermitan lady, whom I knew well, told me that the dead were more numerous than the living in Palermo. One of her ancestors had taken semi-monastic vows after her husband had died and had then asked to be preserved after her own death. I still have the portrait of this woman and, by her cadaverous looks, wonder if it was not painted *post mortem*.

One year a very strange experience befell my mamá, we all thought it was most amusing and, after a little, even she was able to see the funny side of it. Mamá took a great interest in some nuns of the poorest order, the Barefoot Carmelites, who lived entirely on charity. Their pride was an infant Jesus who possessed various sets of vestments for different occasions: for instance,

THE HAPPY SUMMER DAYS

during Holy Week, he was in mourning. ... 'Of himself,' as Mother would add. One day, as a great privilege, the Mother Superior asked her if she would like to visit the convent, which invitation my mother accepted with great curiosity. The inside was humble but spotlessly clean, one whitewashed room after another. She was eventually shown into a big room flooded with sunlight. There, around the walls sitting on chairs, like you or me, were six or eight mummies dressed as nuns all in white. On each lap was a large visiting card with a name. Imagine Mamá's surprise when she read her very own name on the first card she looked at: there it was in bold black lettering, LA DUCHESSA DI VERDURA. I don't think such an encounter could have happened anywhere else in the world.

Death was in the air again during Lent and Holy Week. The preparations were austere. No frivolous reading was allowed, only the lives of the saints, stories from the Bible or, when we were older, pages from *Quo Vadis* or a dreary little novel called *Fabiola*. No music or singing and we would all have to say the Rosary in the evenings. On Maundy Thursday afternoon we went to visit the sepulchres. The carriage was left in front of the Politeama Theatre and we entered the old town on foot – it was considered in the very worst of taste to be seen in any sort of vehicle while the body of Our Lord was on earth. We had to visit seven churches and pray in front of seven Holy Sepulchres. These elaborate affairs were richly decorated with statues, candlesticks, white flowers and some extremely tall kind of grass which had been specially grown in cellars so that it remained completely white. Some of the churches had exquisite floor coverings made for the occasion out of different-coloured sands sculptured into religious mosaics which looked like softly-glowing tapestries. Despite the solemnity of the day, the whole town was out and we met innumerable friends. It was a great occasion for the young men about town who went about pinching buttocks in the crowd: the young ladies were too well brought up to make a scene in church.

At the end of the eighteenth century there had been eighty-two convents in Palermo and many of these had had their own churches attached: in some of these churches, there was an ancient custom whereby the symbolic key to Our Lord's Sepulchre was given in custody to a child for two days. One year I was chosen for this honour by the Abbess of St Caterina. St Caterina church itself was austere on the outside, but inside it was a riot of southern baroque extravaganza full of polychrome marble and gilt wrought-iron gates, behind which I could see the pale faces of the nuns. On the ceiling a glory of saints and angels cavorted and their legs, here and there, overlapped a cornice.

The year I was chosen to be custodian of the key, I was dressed in my best clothes early on Maundy Thursday morning before the church doors were open and given a little satin bag containing thirty silver coins that I had to drop in a platter to repay Judas's betrayal. Once in the church, I knelt in front of the high altar and Monsignor placed around my neck a silver key hanging from a silk ribbon. For the two nights it was in my possession it was placed on a velvet cushion in front of a crucifix. Of course I had to behave myself during those two days, but I didn't mind that as I felt very important walking about with the key around my neck. Incidentally, it was on this occasion that I was presented with the lamb that grew up into that ferocious beast which I have already mentioned in a previous chapter.

On Good Friday, still on foot, we trooped back to the Church of St Caterina, past the fountain of the Praetorian Square, an extraordinary, oversized, round piece of marble bravura boasting naked divinities of both sexes, a row of niches from which protruded heads of strange animals and clumps of papyri. Walking on foot past it for the first time, I noticed that all the noses of the statues had at some time been chopped off and replaced by new ones of much whiter marble. When I asked for an explanation I was told that a Palermitan youth, having chopped off an essential part of Neptune's anatomy in the fountain of that name in Messina, a group of Messinesi had one night revenged them-

selves by rendering noseless the deities of Palermo. I don't know whether this is historically correct or not, but I liked it.

Once in the church we sat underneath a balcony next to a panel representing Jonah and the Whale, an extraordinary piece of multi-coloured marble and metal with verd-antique sea, white sails and bronze rigging. My one aim was to put my hand in the whale's mouth, a feat that could only be achieved by standing on my chair (there are no pews in Sicilian churches) which instantly provoked the stage-whisper of 'Stop it this minute' from Miss Brennan.

The Good Friday service began with the prophecies which seemed to go on forever, then after that came the three hours of agony. Fortunately we never stayed for the entire service for we were expected at the Palazzo Ugo at half-past twelve to see the procession, or rather the processions as there were two of them, and they met in front of the Palazzo Ugo. The old Marchioness there was a cousin of my mother's, gaunt, very dark, with the most infectious high-pitched laugh, and she would have been terribly hurt if we hadn't turned up. Anyway, I wouldn't have missed it for anything. The crowded piazza, the vendors, the blasts of the approaching bands were truly inebriating.

For some Sicilian, and therefore inscrutable reason, Good Friday had been chosen as a fit day for children to wear fancy dress, and you saw little St Rosalies in calico with crowns of roses and little papier mâché skulls in their hands, St Georges in armour, St Lucies in bright green, with a pair of sugar eyes on a plate, even tiny Christs, complete with crowns of thorns and red paint on their sides, but also Garibaldis, musketeers and pirates. Through the midst of this sea of humanity, the band at last somehow made its way, followed by the towering statue of the Mother of God covered in the great, black velvet cape given by Queen Margherita with the *Stellario* behind her bowed head – the *Stellario* was a very large halo made of stars. The statue also carried a long lace handkerchief in her folded hands and in her silver heart were thrust seven daggers; she stood on a pyramid

of candles and was immediately followed by all the children in fancy dress. They came to a stop just under our balconies.

Soon we could hear the sound of an approaching funeral march: it was the other procession bearing the body of Jesus in a glass and silver hearse. On each side of it solemnly marched ten very tall men in armour. These were supposed to be Roman legionaries, but they were also known as the Jews: women would scream insults at them and some would even try to hit them. The Coachmen's Guild had the privilege of organizing and conducting this last procession and each year a delegation came to ask Father if he would lend the family liveries for the occasion. Of course, I would point out this fact to my friends with bursting pride.

By now, the procession had stopped by the statue of Charles v in the middle of the square. With great difficulty, a track was cleared between the Holy Mother and the Saviour. We all knelt on our balconies, then, to the sound of a huge rattle, as bells were used again only after the Resurrection, the two very cumbersome tabernacles shouldered by dozens of men actually rushed at each other like two butting rams, missed by a margin, retreated at the same velocity and repeated this strange performance twice more. The crowds cheered and clapped their hands and the two processions went on their different ways to meet again at sundown in another square. The spectacle was over but, before going home, we were given cups of thick, bitter chocolate.

Good Friday was ordained a day of strict fasting with no milk, butter or eggs, food being cooked only in water or oil; however, luckily, this did not apply to children. Father informed us that our family was exempt from fasting, as we had fought the Moors: this also gave us the right to hang a golden kettle from our coat of arms. But Mamá, either to contradict him or because she really felt that way, said that it was common to profit from this ancient privilege, so our parents fasted just like any other members of the proletariat.

Saturday was another exhilarating day. Again, we walked to St Caterina's. The pictures on the altars and the windows were still

covered with violet hangings, for the church was still doing its best to look sepulchral. It did not succeed – it was almost impossible for such a flamboyant, multi-coloured, baroque church to look anything but joyous. It received us in hushed silence. In front of the main altar, an enormous dark curtain hung from the arch of the apse to the ground; on it, in blacks and greys, was painted the Crucifixion. This great curtain, or *tela*, had been in position for the whole of Lent, but today it was the focus of all eyes. As the office of Tenebrae began and the candles in the church were put out one by one, I could just glimpse the opposite process going on behind the curtain where all the chandeliers were slowly being lit. They looked like constellations flickering through the darkness of the *tela*.

At about half-past eleven, the mass began and I started to fidget on my chair in anticipation of what was about to happen. How slow the priests seemed to be! But I was not the only one getting excited, the whole congregation had become restless and, as the moment of the Gloria approached, the general feeling of expectancy was almost unbearable. At last, when the words '*Gloria in excelsis Deo*' were sung, down came the mighty curtain revealing, through a cloud of dust, the great altar ablaze with candles under an arch of crystal chandeliers. While the organ pealed away and the bells outside rang a Gloria answered by all the churches of Palermo, it was very, very hard not to get up and cheer and clap your hands. The rest of the mass was an anti-climax and was hard to follow. Later on, when I was older, I would rush from one church to another with my friends, hoping to catch a few more *calata della tela*, relying on the proverbial unpunctuality of everything Sicilian.

I have to add a last footnote about the music before we leave St Caterina. Organ music was not the only sort you heard in that church for, on one side, perched on a kind of balcony just outside the apse, was a little five-piece orchestra. During the ecclesiastical proceedings its members would fiddle away gaily not only at church music but sometimes also at pieces from operas like *Traviata* or *Norma*. This practice of mixing ecclesiastical and

secular music could have startling results: Father used to tell of having heard a church orchestra playing an aria from Donizzetti's *Lucrezia Borgia* about poisoning just as the officiating priest put his lips to the chalice to drink the sacred wine!

But to return to the Easter festivities, we always found the carriage waiting for us outside the church on Easter Sunday, for Christ had risen and we no longer had to walk. We would leap in and ask to stop on the way home at the fair in the Piazza Politeama and thence on home to make ourselves sick eating the little marzipan ewe lambs. These sweetmeats were made and modelled by the nuns and looked archaic with their haloes and tiny banners. There were also baskets of fruit and big bunches of grapes, all made from different-coloured marzipans. All the *pasticeria* windows were full of lambs and fruit, but, in our innate snobbishness, we wouldn't touch them even if they had come from Caflish's, the Swiss pastry shop; if some ill-advised person gave us some, we would pass them on to less privileged children.

Easter festivities also included bunnies, chocolate eggs with flavoured insides and those idiotic egg-hunts. Easter Monday was usually dedicated to recapitulations of past delights and savouring new ones to come; springtime, cousins coming to stay, plans for the summer and more time to spend out of doors. Pleasurable thoughts with which to mitigate normal, everyday life with its boring lessons which would begin next day.

There were other religious festivals during the year, each with its special custom and unique flavour, each one a welcome break with routine. December 12 was the day of St Lucia. Protector of Syracuse, she had once saved the city from famine and so one was not supposed to eat bread at her celebrations. This was no privation, however, as instead, we were given delicious, thin maize pancakes called *panelle* and a suspicious-looking, but otherwise palatable, pap called *cuccía* which rhymed with Lucía. There were special kinds of sweets to be eaten on St Joseph's day, 19 March, which was an auspicious day for me as it was the eve of my own birthday and so a day of expectation and speculation as I thought

of the presents to come. Saints John, Peter and Paul all had their special dishes too.

But the great local saint's day was 13 July, when for three days we ate fried sardines in honour of our patron saint – Rosalia, a noble damsel who had abandoned the worldly court of King Roger and had retired instead to a grotto on our neighbouring Mount Pellegrino. The story goes like this. In 1624, her bones were found by a huntsman in a grotto near the summit: he had of course been guided there by a dream about her. Then she appeared to him again in a vision and promised that, if her bones were carried to the cathedral, the pestilence that plagued the city would suddenly stop. As the Italian saying goes, *detto, fatto,* no sooner said than done. The plague stopped within three days and the forlorn saints Olivia, Christina, Agata and Ninfa were dethroned and Rosalia was proclaimed patroness of the city of Palermo.

Before I continue I must make place for an artistic digression. In that same year, 1624, Van Dyck, the celebrated Flemish painter, was finishing the altarpiece for a church called the Oratory of the Rosary of St Dominic. His painting shows the Virgin Mary with the infant Jesus sitting on a cloud dropping a rosary into the upraised hands of St Dominic in the presence of the four patroness saints. Van Dyck was so frightened of the pestilence spreading that he sailed away without waiting to be paid. To explain the cause of his sudden departure, he painted in the foreground a naked little boy running away holding his nose, for in those days it was believed that the plague was caught by breathing. How much of this story is true, I cannot tell, but it certainly has great charm.

But to go back to St Rosalia and her miraculous intervention; every year, a three-day grand holiday was declared to commemorate the event. The whole town was illuminated, Via Maqueda and the Cassaro were lit with great acetylene arches, every balcony and window was draped with exotic hangings from tapestries to humbled bedspreads, no traffic was allowed in the two main streets, several orchestras fiddled away in the squares, vendors of

all kinds invaded every corner with their *bancaralle* and, all through the night, rockets resounded in the warm air. On the last day, there was a great procession of all the male saints, each one on his own chariot drawn by man-power. St George on his charger was carried in an up-and-down movement simulating a canter, the saints Cosiman and Damian walked abreast very slowly as befitted the patrons of doctors and physicians, and St Roc with his dog and cane came clippety-clop as he had a sore leg. The female saints were considered too exalted to walk on foot and so stayed at home in their churches.

Finally, preceded by a brass band drawn by eight white oxen, the great silver casket of St Rosalia herself appeared, carried on top of a high scaffolding of papier mâché clouds, followed by the Cardinal and all the clergy. The day ended with a gigantic display of fireworks by the sea in front of the Marina and a deafening concert of mortars. To tell the truth, I only saw this famous procession once, for it was right in the middle of the bathing season and we didn't want to miss three days on the beach. But we always went to watch the fireworks from the Trabias' terrace.

On 4 September there was a pilgrimage to St Rosalia's sanctuary on Mount Pellegrino. We were never in Sicily at that time of the year, so I didn't witness the pilgrimage until much later, but I once went as a child to see the saint's grotto. (Nowadays, the journey up there takes a few minutes by car, but then it was an adventure that lasted all day.) We travelled by donkey along the old, winding, cobblestone road that climbed laboriously between rugged rocks with no vegetation at all except for tall clumps of sweet-smelling broom. The sanctuary monastery was embedded in the cliff, and we entered the cave through a gate, to the sound of dripping water. As the water oozed off the cave's ceiling, it was collected into a maze of lead pipes which ended in a cistern. Looking round cautiously in this dank cavern, I caught sight of a statue of the saint under an altar, sleeping, with her head resting on her hand. Nobody else was around, just our small family group. I began to feel alarmed, for the flickering lamps gave the illusion

that St Rosalia was breathing. The sound of vespers being chanted at the other end of the dark cave increased my uneasiness and I began to tug at Miss Brennan's skirt; even that seemed cold and damp. I started to cough and announced that I was catching cold. How comforting it was to come out and see the blue sky and feel the warm sun on my face. One of the donkey drivers then took me on foot to a rocky prominence, from where I could see La Favorita and my beloved Villa Niscemi far below: how small they looked, like toys.

Even on ordinary days, to walk through the streets of Palermo was an exciting adventure – not the modern part of the town with its straight, wide streets devoid of charm or surprises, but the old part of the city. Sometimes we were taken to see some distant relative in some sombre house in a dark, winding street or in an ancient market square, like the Trigona Palace in the Piazza Fiera Vecchia with its *bancaralle* surrounding the fountain of Panormus, the genius of the town, a bearded old man with a crown, holding a snake in his hand, sitting on a pile of stones.

These forays were doubly fascinating because they did not happen very often and they brought new experiences at every corner. The fan vendors, the pyramids of prickly pears that the men could cut open in three movements without getting a single thorn in their fingers, the organ-grinders, the street singers and the story-tellers pointing with a long stick at the painted scenes of Charlemagne and the Paladins.

What I longed to stay and watch was a puppet show. I did so want to see the Paladins fighting in armour and turbans, for I was never allowed to go into the puppet theatres in case I caught fleas or something worse. At long last, at a children's party, I managed to get a glimpse of a refined version of their antics and, sadly, Rinaldo, Orlando, Clorina, Marfisa, Armida and the rest bored me to tears. The older children got frightfully excited, whilst the younger ones were terrified by the yells and the clanking of arms.

A familiar figure in the streets of Palermo in my youth was the water-seller. Wearing a blue apron, he stood by a low table which

held the glasses. The water was in a big earthen amphora and, from this, he deftly poured water into the glasses, balancing it on one knee without spilling a drop. Then, from a metal beaker, he would drop in two or three dashes of *zambu*, an aniseed-tasting liquid not unlike the Greek *ouzo*. The table itself was painted in gaudy colours, had tassels, knobs and a bunch of whatever flower was in season. Sicilians were not heavy drinkers, I seldom saw a drunk in the streets, but, especially in summer time, they consumed a prodigious quantity of lemonade, orangeade, milk of almonds and just plain water.

But, best of all, the Sicilians loved ice-creams with picturesque names. There were *sorbetti, granite, spumoni, cassata, tutti-frutti, giardinetto, moka* or *croccante con panna* to choose from and, of course, all the fruit ones, strawberry, peach, apricot and pistachio. There were several renowned *gelateria*, two or three on the Marina and near the Massimo Opera House, but our favourite was *Mommo ai Leoni*, the *leoni* being two sphinx-like lions on each side of the main entrance to La Favorita.

Mommo had his *gelateria* in the square of the lions. How many times, coming back from Palermo, did we stop to have a delicious strawberry and whipped-cream ice before going home through La Favorita? We didn't even have to leave the carriage for the waiter would bring a tray of ices to us and we would eat them right there, while the coachman had his on the box and the footman his standing by the door. To go and sit at one of the tables on the pavement was unthinkable! Those who had their own carriages also did the same thing on the Marina, but it was considered in the worst possible taste to eat ice-cream in a hired cab. These sedentary habits extended to other fields. A lady of rank did not condescend to enter a shop (except when she had to try on a dress or a hat), instead she had any article she wanted to purchase brought to her carriage, at great inconvenience to the traffic. I must add that this did not happen very often, as most of the shops sent samples round to people's houses on request, so that things could be chosen at home.

For those who couldn't afford an ice-cream, there were the water-melon vendors, sitting under awnings by pyramids of melons ready to be cut, a few slices on view to demonstrate how red they were inside. (It was rumoured that if one of the slices was too pale, it was rubbed with a ripe tomato.) These amiable and inviting gentlemen proclaimed their merchandise in stentorian voices with the slogan: 'Eat, drink and wash your face for one sou'.

Another character who could still be seen around then was a *caramellaro* surrounded by eager, scruffy urchins. He stood holding in his right hand a string about a foot long, from which hung a piece of oval-shaped sugar candy; in his left hand, he held a big silver 'onion' watch. He permitted the customer, who had paid his fee, to suck away as hard as he could for exactly one minute, after which a little bell in his watch would ring and then the highly hygienic sweetmeat would be yanked out of one mouth immediately to be inserted in the next. Needless to say, there were frequent arguments and some boys got their ears boxed because they wouldn't let go. This game was advertised as 'a sou a suck'.

There were many street vendors who intrigued me with their cries: for instance, the young man who balanced a square platter on his head and shouted, *'Quaglie, quaglie'* only he wasn't selling quails, but big, fat aubergines, fried, skin and all, in olive oil. Then there was the whistle of the peanut vendor or the women selling tiny snails cooked in tomato goo: you couldn't eat them without making a sucking noise, which caused these ladies to cry in ecstasy *'Ma chi sunnu vasi?'* (What are they, kisses?)

Some mornings in May or June, I would see men and children with red carnations behind their left ears. They all came from the old market place where the fish were sold and their carnations meant that there had been a good tunny fish catch in that day and that prices were down. If you took the trouble to go to see for yourself, there they would be, blue-black, shiny monsters, each with a red carnation in its mouth.

In April, in spite of cosy, southern kitchen smells, one was

always conscious of the scent of orange blossom coming in whiffs from somewhere. In June, it was the turn of the jasmine. At sundown, like a storm of vociferous starlings, a crowd of young boys would appear carrying, on top of long canes, dozens of round bunches made entirely of jasmine flowers, like fluffy, sweet-smelling snowballs. They invaded every open door of shop, house or vehicle, pushing their wares under one's nose. Sometimes Grandmamá and Mamá would come back loaded with jasmine and we could smell its sweetness even before they emerged from the stairs into the hall where we were waiting for them.

Writing about these things, I realize now the different smells of my childhood made a rich, odoriferous background to my everyday life. In the morning, the delicious aroma of roasted coffee coming from the servants' quarters, gently invading the rest of the house; floating up from the courtyard, the stables and the invisible hencoup, depending on the seasons, would come a mosaic cloud of different smells mixed with hay, straw and even manure; altogether they formed a wonderful pot-pourri. The odour of the saddle-room was particularly intoxicating and so was the smell of the soap with which the carriages were washed. Upstairs, in Mother's room, Roger et Gallet's Carnation won the battle over the faint *papier-poudre*, whilst Grandmamá's emanations were strictly from Joseph Maria Farina's eau de cologne. I shall not mention those odious baboons again, but instead linger on the sweet scent of flowers in the garden, on the profusion of gardenias stephanotis and those giant magnolia grandiflora blooms that could not be kept in a room for too long because they gave one a headache. This, though, was surely a legend, the truth being that after a while the sweet intensity of the perfume became rather sickening.

But to return to Palermo. In those faraway days of my childhood, it was a city of palaces and churches, with all the allure of a baroque capital. At least twenty aristocratic families still lived in their own ancestral homes on the Marina, the Via Maqueda and in the narrow side streets. In some cases, they existed in half-empty

rooms hung with cavernous-looking family portraits, clinging to the few tangible witnesses of past glories. But others were very grand and beautiful. The Palazzo Butera appeared to be the biggest of them all, with its immense terrace overlooking the sea and, what seemed to me, an interminable vista of drawing-rooms. Here lived the Prince and Princess of Trabia with their three sons and two daughters.

The Gangi Palace was, and is, spectacular with its hanging garden and mirror gallery. The ballroom scenes for the film *The Leopard* were shot here. The Valdina, in a street so narrow that it was practically impossible to see its façade, surprised me by its cheerful interior. The ballroom had a majolica-tiled floor that exactly matched the ceiling, like a reflection in water. The Palazzi Ugo, Villafranca and Riso were in the square where we always went on Good Friday. The Mazzarino boasted a gigantic statue of Minerva, seated, with helmet and shield, and a terrace from which sprouted a sprawling, centuries-old tree: how could it have grown on the first floor and where were its roots? This was always a mystery to me. The tree was some kind of *ficus* and kept dropping tiny round berries on my head whenever I went there.

On the Via Maqueda was the Santa Croce with twin staircases and lugubrious, very high-ceilinged rooms – at least, that is what I remember. Opposite was the Montevego, inherited by a red-haired family who were in some way related to us. The Palazzo Trigona was an elegant sixteenth-century building where Clementina and beautiful Giovana, daughters of the ill-fated Countess Trigona, lived. The Countess Giulia Trigona was the central figure and victim in a famous *crime passionel* that shook the very foundations of Italian society. A lady-in-waiting to the Queen, she was at the time in Rome in attendance at the Quirinal. From there, she slipped off to a shabby hotel near the station where she was stabbed to death by her lover, who also belonged to a noble Sicilian family.

The Sciara was a smaller house, but had a ballroom that was said to be haunted by a Turk. The Turk was supposed to be the

ghost of a Moor chieftain, emir or whatever, buried in the garden next door. This garden was part of a fort-like palace that had belonged to the extinct house of De Cordoba whose coat of arms featured a turbaned dark man in chains. I don't remember the Lampedusa palace well, having seldom been inside, but I have vague memories of a pretty little terrace with white and blue tiles.

Of our friends, the Scalea, the Mirto, the Baucina and a few others lived in their own houses. During the upheavals that had marked the first half of the nineteenth century, several fortunes had been made and these *nouveaux riches* had moved from the provinces into town and had built for themselves grand villas in fine gardens all around Palermo, had intermarried with the old families and, as in Britain, had acquired titles. My own dear grandmamá was a great heiresss, being the only daughter of Baron Favara. When she had married at the age of sixteen, she had gone to live at the Palazzo Niscemi in town. Completely redone at the end of the eighteenth century, all it retained of the old building was an extremely elegant portico with slender columns on the first floor of the courtyard. The villa of my childhood near La Favorita park was in those days only used in the summer, but gradually the family prolonged their stay there a little more each year until eventually they left the town house in Palermo completely. My grandmother's son and heir, my Uncle Peppino, finally lived in it with his wife, Aunt Beatrice, *née* Gangi, and their three boys.

9

IN THE LATTER PART of August, we started on our annual continental tour. For months before Grandmamá had been busy with books, brochures and consultations with Cook's Tours, trying to decide in which direction she would steer our little caravan: Vienna and the Semmering, Bavaria and the Ludwig II *Schlossen*, Munich for the *Oktoberfest*, or Budapest and Lake Balaton. Once we explored the *châteaux* of the Loire in a rented motor-car from the Metropole in Tours. Then, of course, there was always Switzerland, dear old reliable Switzerland, with its lakes, funiculars and well-trimmed gardens of begonias and flower clocks. To these Alpine surroundings we would return over and over again. Chillon, the Jungfrau and Pilatus had no surprises for us and we were quite at home at the Beaurivages and National hotels.

But wherever we had been, October would find us in Paris

for two or three weeks before our leisurely homeward journey with stops at Milan, Venice or Florence and of course Rome and the dear old Grand Hotel to see the cousins; we *had* to be back in Sicily for All Souls' Day on 2 November. When I was too small to be dragged from cathedral to cathedral, Maria Felice and I would be dropped on some mountain top in Tuscany, Vallambrossa, Camaldoli or l'Abetone, before going to Paris. I can hardly remember these mountain holidays, but it was then that I made friends with other children from Roman and Florentine families who were also marooned up there, friendships that have lasted a lifetime.

The actual operation of departing on one of these holidays was neither easy nor rapid. For days before the actual date, the entire household would be in a state of utter confusion: gaping trunks, suitcases, portmanteaux and hat-boxes scattered all over the place, piles of underwear and coats littering the floor – for no one knew how cold it might be in Chamonix in September or even in Paris in October. I profited from this disorder by hiding some forbidden toy between the dresses and shawls. As the day approached my excitement mounted to a fever because, for me, this was an adventure, actually boarding a boat, seeing the black mountains of Sicily slowly vanishing in the sea under a starry summer sky, being cut off from all of my world.

The prospect of seeing cities and places I had never seen before, of hearing different languages, perhaps being in a railway accident or even shipwrecked, was intoxicating. So, for at least a week ahead, I would be ready for the take-off with a very disreputable-looking personal bag hanging from my shoulder, hugging my teddy bear. Marie Felice took a different view of the matter. For her the pleasure of travelling was spoiled by separation from the dogs and Father (strictly in that order).

As well as the four of us, there would be Sandrina, whoever else Grandmamá had as maid at the time, and Pasquale, now promoted to the role of courier. He was perfectly hopeless in this capacity as he spoke only Sicilian. He was sent on one day

ahead to fix up suitable accommodation, but, to the fury of my grandmother and the annihilation of Pasquale, his choice was usually disastrous.

The boat left Palermo about half-past six in the evening. We always piled into the carriages and arrived at the pier much too early, so we had to hang about, restless with excitement, with the friends and relations who had come to bid us good-bye. It was an animated sight, as each traveller had at least a dozen well-wishers to see him off. Father, naturally, was always there, rather relieved I think, to see the last of us for some time: now he could make plans of his own. There were a few relations, Aunt Beatrice with one or two of her boys, the old lady whom we called 'dear old Monte', a few other friends and the men from the *amministrazione*.

We were not a kissing family and there was very little of that nonsense at our parting, but you should have seen the goings-on all around us. If the voyagers had been embarking for Cayenne or Alcatraz, the separations could not have been more heart-rending or loud. Even for newly-weds starting on their honeymoon, there were tears, sobs, lamentations and kisses! Whoever hasn't witnessed the separation of a Sicilian bride from her family just doesn't know about ferocious-impact kisses. Noisy smacks, wet with tears, sticky, prolonged ones, the cheek wiped with a dirty handkerchief before the planting of yet another succulent kiss on the same spot, were followed by lamentations, semi-fainting fits and invocations to the Virgin and St Rosalia. The culmination of all this we used to call a 'kissing fry-up'. Beginning with the eldest of the family, the victim was locked in a bearhug and kissed all over the face with the rapidity of a machine gun with noises suggesting the frying-pan. Then the next one tore the first away and repeated the operation, down to the younger ones till eventually children were held up to salivate what remained of the hapless bride's face. But the moment the last siren had honked and all were aboard, everything changed to excited gaiety. Handkerchiefs waved, music started, jokes were exchanged (salacious ones for the honeymooners), flowers were thrown,

recommendations exchanged and names called – 'Totoo', 'Peppinoo', 'Sisidda' or 'Santina' – while the chains were pulled and, amid indescribable din, the *Citta di Catania*, as one of the liners was called, slowly detached herself in a great foam of water, while the crowd ran forward to the end of the pier waving and shouting as she majestically passed on her way out of the harbour.

Early next morning we would arrive in Naples. Dazzling sun, yelling coachmen cracking their whips to attract attention, *scugnizzi* turning somersaults, smells of dried fish and smoke from the stoker – such were my impressions of that city. Our party was always met by an old man in uniform and cap, whom we called the Captain. He was supposed to pilot us to the wagon waiting on the pier, accompany us to the central station, see us on to the *diretto* (express) train and thus on our way to Rome.

For a child, travelling by rail in those distant days was a momentous occasion and at times most rewarding. There were four of us in the first class, Grandmamá, Mamá, my sister and myself. But in spite of the numerous handbags, portmanteaux, books, lunch baskets and teddy bears, we couldn't quite fill all the seats in the carriage. It was fine while the train was still in the station as the maids and Pasquale had been instructed to remain with us, fussing around with coats and luggage to 'make crowd' as we called it, but, as soon as we were off, they had to go to their own compartment in the second class, leaving two seats available for eventual strangers. As long as the train moved, everything was all right, but, as soon as we stopped, the danger of some interloper invading our territory became acute. So my astute grandmother invented a strategem to defend our citadel. At every station I was made to stand at the window, jump up and down, pull faces, pretend to fight Maria Felice, and generally make myself sufficiently odious to scare away any prospective traveller. How I enjoyed this! After all, what child is allowed, nay, *commanded* to be perfectly outrageous by his own elders? Naturally, being a born ham, I soon over-acted and the hair-pulling having become too realistic had to be dropped.

This stratagem often succeeded, but it was hard on me, after these welcome excesses, to have to sit down quietly in my corner and behave myself till the next station. Unfortunately, we always took fast trains that rarely stopped and I longed for the ones with the sign *accelerato* that stopped at every little town. So, forerunner of the modern worker, I went on strike and firmly refused to perform unless my demands were met and, what's more, I threatened to tell all to the governess when we returned, for I knew she was bound to disapprove. One of my demands was to be allowed to climb on to the luggage rack and stay there in between stations, the other was to use a knife at my next meal. I can't remember what the outcome of all this fuss was, but I do know that after intense and prolonged sulking I did, at least once, climb on the rack – it was near Lucerne and I had to come down again quite soon because from up there I couldn't see the Lake. This lake had a particular fascination for me as I used to play a game in which I would ask the victim if he had ever seen or heard of the 'Lac des Quatres Cantons'. Then I would ask him to open his right hand, palm upwards, so that I could point out the four cantons of Lucerne, Uri, Unterwalden and Schwitz (I loved to pronounce the last one). I would then innocently enquire, 'Don't you know where the lake is?' Some people were even foolish enough to ask this question themselves, whereupon I spat into the middle of their hand . . . my God, I must have been a pest.

The *wagon-lits* sleeping cars were another source of awed delight and wonder. The brown-uniformed attendants, the soft-carpeted corridors, the upper berths and, most of all, the wash-stand with its cryptic message *'sous le lavabo se trouve un vase'*; the peculiarly-elongated chamber-pot concealed in its interior at a forty-five degree angle bewitched me and was the source of much mirth to my sister and me. Whenever we decided to shock some guest at the villa, we would intone in unison, *'sous le lavabo se trouve un vase'*, just as the sauceboat was being brought to the table at lunch or dinner. This joke exasperated the family and

disgusted Miss Brennan, but it very often fell flat on the guests, some new official or obscure aunt perhaps, because they'd probably never been on a *wagon-lit*, nor, possibly, did they understand French.

During our travels we saw much that greatly impressed us then, but which now would seem even more startling, visions from another century, which in fact they nearly were. In Vienna we used to go and see the old Emperor Franz-Joseph come out of the Hofburg at four o'clock in an open victoria carriage, all alone, saluting to left and right without ever changing the expression of his face. There was no cheering or anything of that sort. On the Ringstrasse, the men doffed their hats and the ladies curtsied with great calm and dignity. No police or bodyguards were visible and there was no commotion. We also had tickets once or twice for mass in the Hofburg. What impressed me greatly were the guards at the elevation of the Holy Host, presenting arms, kneeling on one knee.

But most of my memories of Vienna concern opera. I remember being taken to hear Caruso in *Rigoletto*: he sang in Italian, and the rest of the cast in German. The theatre was full of Italians and at the end there was an ovation, they brought a laurel wreath with an Italian ribbon . . . and I burst into tears. The first time I saw *Rosenkavalier* was at the Hofoper and it was love at first sight. There was also a never-to-be-forgotten matinée when we had a box for *Don Pasquale*. During the interval I was, to use a very common expression, taken short. Mamá asked where the Gentlemen's might be, and I was unleashed to get there by myself. I got there all right, but when I tried to get out again, in spite of all my efforts, the door remained implacably closed and I was trapped. I prayed for someone else to come in and use it. Time passed; anxiety and then despair got hold of me. In the meantime, the last act had started: '*Com'e gentil la notte a mezz' april*' and no little Fulco. Mamá, seized by panic, ran out to find me, went to the Ladies', where obviously I was not, finally discovered the site of my imprisonment and we held a dramatic conversation in

Fidelio tradition through the door: then off she went to find help. Nobody would listen and she was shushed for disturbing everyone. Eventually the woman in the Ladies' took pity, or at least understood that a child was trapped; she found the keeper of the Gentlemen's, who was out in front enjoying the opera, and persuaded him to come with his bunch of keys. After several attempts, he finally opened the prison door and I escaped, to be congratulated and petted by the few people who had gathered. ... By the time I got back to the box, to the reproving looks of Grandmamá and the giggles of both Maria Felice and our cousin, Maria Giulia, who was travelling with us that year, the opera was nearly over. I had to wait many years, until after the war, to hear the aria *'Com'e gentil'*.

Our hotel was the Imperial Hotel on the Ringstrasse; it was very impressive with a great marble staircase and red carpets. When not listening to music, we used to visit the big wheel in the Prater, Demels Conditorei and a wonderful toyshop with three whole floors of toys.

One year we went further down the Danube to Budapest. What I liked best of all in that Magyar metropolis was Gerbault, the famous cakeshop, where a mammoth display of every kind of sweet and pastry was exposed to my greedy eye and watering mouth. Making my choice was agony as, officially, I was only allowed three. A pretty young girl would pick up the chosen ones with a pair of little silver tongs and bring them to my round, marble-topped table. Exactly the same protocol was enacted at Demels in Vienna or Rumpelmeyer in Paris, but I always felt that the Hungarians managed it much the best.

Another particular attraction of Hungary for me was walking by the river in Budapest: it was part of the town itself, its very lifeblood. In Vienna, I never even noticed the Danube. But these expeditions to Vienna and Budapest were exceptional. Usually we went back year after year to Switzerland, as Grandmamá greatly admired its tidiness, punctuality and well-controlled romanticism. I got rather bored going from one large hotel I knew already to

another equally vast one, with no friends to play with. Even the little steam-boats on the lakes lost much of their charm and I got sick of all those edelweiss, as I hated to touch them. Of course, Maria Felice took advantage of this and delighted in sticking them down my neck.

But we did have two glorious adventures one year. It must have been, I think, in 1911 or 1912. In those days motor-cars were not allowed in certain alpine areas of Switzerland: crossings had to be made by hired coach. Grandmamá, who had a sense of the romantic in her, decided to tackle the St Gothard, a journey which started at a village called Goëschenan and, after three days, ended at Ajrolo. As usual, the party consisted of the two ladies, my dear cousin Maria Giulia, Maria Felice, myself, two maids and the more-and-more-bewildered Pasquale. We had to start early in the morning and it was barely daylight when we woke up in a state of intense excitement. We were all in the room Grandmamá shared with the two girls: she was having her hair done, while Maria Giulia and I were scanning the horizon through the windows in search of our first chamois. Maria Felice was still in bed when, to our frozen horror, from underneath her bedclothes, a muffled sound of unmistakable nature reached our ears. We cringed in anticipation of the Olympian wrath to come as anything of that nature was totally unthinkable near the august presence of Grandmother. The poor maid, comb in hand, stood behind her, petrified. After moments of chilling silence, to our surprise and utter relief, taken perhaps by an alpine spirit of adventure (or was it a Byronic souvenir?), Grandmamá waved her hand towards the window uttering one single word: '*Avalanche!*'

> The avalanche on his head
> But ere it fall, that thundering ball
> Must pause for my command. . . .

The coach itself, if memory serves, was a cumbersome affair drawn by four horses. The central part, like a landau, could seat four to six people inside, but, as the weather was exceptionally

fine, it never had to be closed. In the back of the coach, but on a higher level, there were two more seats and then another two on the same level with their backs to the coachman's box that was situated the highest of all. We naturally wanted to be in the back out of range of the ladies' eyes, but I, being the youngest and the most uncontrollable, was nearly always made to sit inside. Only on the last day did I manage to sit by the coachman and wave his long whip. We spent two nights in neat inns in trim little villages whose names I have forgotten. Both the Rhine and the Rhône are born in the *massif* of the St Gothard and we saw the spring of the latter: a little rivulet hurring over pebbles. I, who had seen its breadth in Provence, was very much impressed by this. What was particularly attractive about travelling by coach, especially the first part when we were climbing and the horses had to go very slowly indeed, was that we could get out, stretch our legs, gather gentians and daisies and join the coach again after the next curve. Up to the second half of the last century everyone had travelled by coach; how strange it was to do likewise.

Another great alpine experience was an excursion up the Jungfrau. Now do not think, please, that we climbed all the way to the top with nailed boots, alpenstocks and ropes, because reality was far more prosaic. I cannot remember if this excursion took place the same year as the coach expedition over the St Gothard Pass, or whether it was the one before: all I know is that it was the year of the cholera and we were sent to Grundelwald for several weeks, where we met and made friends with a great many children who were there for the same reason. One day we were all taken to Interlaken at the foot of the Jungfrau, where we got into a funicular which went through a long, frightening tunnel until we finally emerged on to a terrace with a magical view; a great white vale with blue pinnacles sticking out here and there. From time immemorial, we had always laughed at those road signs with the words *Zum Blick* and an arrow pointing to the view. Something about those two informative but otherwise inoffensive words provoked our hilarity. Well, here we had the highest *Blick* we had

ever seen, the blick to end all blicks. It made the Righi one opposite Lucerne look accessible and tame.

The Stelivo Pass was less exciting. To begin with, we started from St Moritz leaving behind us the comforts of the Palace Hotel, then there wasn't much climbing to be done as we were already at a very high altitude and, though I had been told that on the pass itself I would find snow, when we got there all I found was a patch or two of blackish matter around the inn where we had lunch. After that a slow descent into Lombardy to Chiavenna where we found once more the present century waiting for us in the shape of a train that puffed and whistled us all the way to Milan.

Milan was a city which I felt I had good reason to dislike, having had two unpleasant experiences there. Walking in the public gardens one day, I had been attracted by a lake full of Asiatic geese – I was, however, less enthusiastic about them after I had fallen in on top of them! The other experience occurred one day when we had had to put on our best clothes as we were expecting friends to tea. Mine consisted of black velvet trousers and a white silk shirt. I'd never worn either before – it was much too early in the season for velvet – but I had made such a scene that Mother had had to give in. One of the visitors, a boy of my own age, Mathieu Pozzo di Borgo, who was extremely mischievous and frankly unbearable, found some paints and, whilst I was engaged in earnest conversation with a girl called Maria Terese Massari whose great blue eyes enchanted me (as they still do), he drew a grinning round face with horns in crimson paints on my back. It never came off and the shirt had to be thrown away. Later, the perpetrator of this outrage became one of my best friends.

I much preferred Paris to Milan and, as we went every year, I was much more at home there. Throughout my life I have returned to Paris over and over again, I've even lived there for several years, but if I close my eyes and try to recapture its spirit, it is the noises of those faraway days that come back to me. Mauve October evenings, the clip-clop of horses' hooves on the wooden

paving blocks, the few raucous honkings from motor horns, newspaper boys shouting '*Paris-Sport*'. My sister insisted that what they were yelling was '*L'Aristo*', meaning that the revolution was about to return; she said this to frighten me, the sweet creature. Then there were the gas lamps being lit one by one, noiseless, invisible rain falling and enveloping everything in wet grey mist so that even the Colonne Vendôme disappeared. How secure I felt in our cosy rooms, surrounded by those I loved, as I looked out of the window at the light dimming in the rue de la Paix.

Some of our afternoons in Paris were spent visiting friends, or those who had once lived in Palermo, others were filled with dull, dutiful visits organized for us by Mamá. My sister had a friend, an extremely pretty girl called Loulou Rousseau, whose father had for years been Consul-General at Palermo – we often went to visit her in the rue de Ranelagh. The Duke of Camastra lived in Passy and, as he was a brother of our friend, the Prince of Trabia, and as the Duchess, born Ney d'Elgingen, was an intimate friend of my mother's, we had to go to play with her two nieces, Paule and Caroline Murat, which pleased neither them nor us, as we had absolutely nothing to say to each other.

We much preferred afternoons in the Tuileries gardens where there was always an old man with a flowing beard, who had the gift of charming birds. He would sit down on a bench and all the sparrows would come and perch on his shoulders and battered old hat. Talking of birds, we often saw a woman pushing a small cart full of herbs and, as she went along, she cried, '*Mouron pour les petits oiseaux*' – *mouron* being some kind of grass and not, as you might think, a derivation of the verb 'to die'. The *guignol* was always despised by us and so were those goats and donkeys and their dirty little carriages.

Fun was to be had, too, at Le Jardin d'Acclimatation feeding seals or riding on elephants or tame zebra. The other zoo, Le Jardin des Plantes, we frequented much less; it was too far away and there wasn't even a pony or a donkey to ride on. Another

source of excitement was riding on the *montagne Russes* or seeing oneself in the distorting mirrors at the Luna Park. There were several little bridges where air blew up the skirts of the unsuspecting ladies walking over them; our joy was to entice the helpless Sandrina on to one of them. These months of travelling were made so much more free and enjoyable by the absence of Miss Brennan or her successors, who always went home for their holidays. Sandrina, poor dear, was in charge and she was putty in our hands.

She took us to see the various circuses, the *Medrano*, the *Nouveau Cirque* and the *Cirque d'hiver*, and once or twice she let us have tepid tea at the Palais de Glace. We never actually tried skating as we shouldn't have known how to – we simply went there so that we could tell our Palermitan friends on our return that we had been there, adding that we had had a skating instructor who wore a golden, frogged coat and an astrakhan cap with an aigrette and that he had taught us to do figures of eight and to waltz. These were easy lies as there wasn't the slightest chance of being challenged on ice in Sicily.

Occasionally, either Mamá or Grandmamá would feel our lives were too frivolous and so we would be forced to go to children's matinées at the Comedie Française, where we bored ourselves to distraction yawning through *Le Bourgeois Gentilhomme* or *Les Femmes Savantes*. In compensation we had the Chatelet, that venerable theatre on the square of the same name, home of a special kind of spectacle called *feeries*. These were not far removed from British pantomimes and were often, in fact, based on fairy-tales like *Puss-in-Boots* or *Cinderella*, or on Jules Verne books like *Michel Strogoff* or *Around the World in Eighty Days*. The great moment which put a lump in my throat was the scene where, before blinding Michel (a big sword was reddening on red paper flames), the torturers said: 'Look, look at what you will never see again,' at which scantily-clad, oriental-looking ladies began cavorting voluptuously around the poor, chained hero. As I don't want you to be too concerned about his fate, I will tell you that in the last act he regained his

THE HAPPY SUMMER DAYS

sight. In *Around the World*, the climax was an attack on a train by mounted Red Indians. The actual train was fixed in the middle of the stage, but on each side were two moving carpets like the escalators at Harrods, only flat, going very fast in opposite directions. By this ingenious device, the horses, although actually galloping, always remained in the same place. Add to this Indian yells, pistol shots, flying arrows, a backdrop of fir trees and a great deal of smoke, all to the sound of a thundering orchestra, and you will have some idea, though but a faint one, of the devastating effect that this scene had on the shattered nerves of a little boy. The posters outside proclaimed that these performances were grand spectacles and indeed they were if, after so many years, I can remember them so vividly.

One year I had another revelation, Maurice Maeterlinck's *Bluebird* at a theatre in the Champs Elysée. The play was about two children, Tyltil and Myltil, who, accompanied by their dog, Patou, set forth on a quest for the bluebird of happiness in order to take it home to their poor parents. They searched in the strangest of places, such as the land of dreams, where they found their grandparents dozing in front of a cottage. People here could only come to life again if someone thought of them and, sure enough, Granny woke up and said, 'Good heavens, someone is thinking of us . . .' They also visited a cloudy abode which children inhabited before they were born; here, each baby had a bag which contained their future deeds, good or bad – one poor little fellow was told that he had a crime in his! These people were waiting for a call from their mothers so that they could come down to live on earth and, sure enough, the distant chorus of mothers was soon heard. Myltil and Tyltil also visited a great cave where diseases lived and where they were rapidly being defeated by modern science, all except for one in rude health which kept jumping around sneezing and coughing . . . the common cold. The children were frightened when they visited a churchyard, then a fairy appeared to tell them that there were no dead and instantly the tombs all opened up and out came a profusion of lilies. Then, far away on a hill, appeared a tableau

129

of the pageant of joy: the joy of telling the truth, of giving and of loving (one's parents I supposed). At the front were the general, everyday joys, trivial sprites in the shape of young ladies in short tunics dancing on a green meadow dotted with flowers: here was the joy of making a nosegay, the joy of listening to a bird (alas! not blue), the joy of drinking from a spring, the joy of running barefoot in the dew. (This last one was our favourite and we couldn't wait to get back to the hotel to try it out by sprinkling water all over the carpet.) Sadly, in all their meanderings, the children never found the bluebird because, in fact, it was there, in their own home, and, when they returned empty-handed and tired, they found the bird singing its blue head off in a little cage. It had been there all the time, but the children had never looked closely enough at it and so had thought it was brown. (Perhaps they ought to have visited an oculist!)

If the mysticism is sugary, the moral is strange because why was happiness kept in a cage anyway? It's all very well to describe *Bluebird* in disparaging terms now, but to me, at the age of eight, it was pure magic and afterwards I would dream of Georgette Léblanc in golden sequins as the fairy of light.

Ferocious historical characters also used to haunt my dreams after a visit to the Musée Grevin, the French Madame Tussauds. There, you found Napoleon and Josephine, Charlotte Corday killing Marat, the little Dauphin in a prison full of rats and the Christians in the Coliseum ready to be gobbled up by lions. Most provoking of all were the statues dressed in modern clothes, either sitting or leaning against a column, mingling with the real crowd of visitors. Our great game was to stand very still and pretend to be a wax figure. Cousin Maria Giulia was adept at this, for she could stand petrified for a long time without batting an eyelash, even if someone touched her, then she would suddenly move away, creating a sensation. Once, whilst indulging in this mystifying sport, I was sitting on a red velvet settee in my Peter Jones sailor suit – difficult, as my feet didn't reach the ground – when an inquisitive, freckled little French boy became much too familiar

THE HAPPY SUMMER DAYS

and tried to lift the whistle out of my breast pocket. This, game or no game, was too much for me and I had to let him have it and so I slapped his nosey face. He howled. An irate mother in a wobbling hat arrived to be confronted by two adolescent viragoes, sister and cousin, ready to join in the fray: with Italian cunning, they pretended not to understand a word of French and the fight began. Providentially, a uniformed attendant arrived to separate the warriors and, not too politely, show us the door. We were left panting with rage on the pavement of the boulevard aptly called *des Italiens*.

Minor pleasures were visits to the Galéries Lafayette and to my favourite Printemps, where I discovered the delights of the escalator for the first time. These Parisian weeks passed all too quickly and soon we were once more on the Gare de Lyon on our way home. The usual stops in Venice and Florence, and a week or so at the Grand in Rome. If Maria Giulia was travelling with us she was dropped there to our great regret and we continued our trek south to our native land.

Coming home, the great disappointment was that we were in bed when they put the train on the ferryboat to cross the straits of Messina as it happened at night and we were not allowed to go on deck. But the idea of being in a bed on top of a boat was most stimulating.

10

ABOUT THREE KILOMETRES away from Villa Niscemi lived an English family, the Whitakers. Or rather the Robert Whitakers, to distinguish them from the other two branches of the same family who also lived in Palermo. The Roberts were installed in the Villa Sofia at Partanna in our vicinity, while the Josephs lived at the Villa Malfitano in a great garden and the Joshuas in an unexpectedly Gothic Venetian concoction in the Via Bara in the heart of town. They all belonged to a Marsala wine dynasty, having inherited this empire from one Benjamin Ingham whose sister was their grandmother. At least that is what I have been told. For two obvious reasons, we children were much more intimate with the Robert household; they were our neighbours and the youngest daughter was just one year older than I. But both my mother and grandmother were on intimate terms with the other two families whose children were much older than us. These were easily distin-

guishable by their difference in height and size, the Joseph girls being tall and slim and the Joshua girls round and small.

Mrs Tina Whitaker, tall, gaunt, unsmiling and caprine, ruled at Malfitano. Her husband, the gentle Joseph or Peppinine, as she called him, had a small museum of moth-eaten stuffed birds and was interested in Phoenician antiquities that he dug up on his island of Motya. Their two daughters, Norina and Delia, very prim and versed in genteel accomplishments, were of no interest to me except that they bore the same names as Mrs Brown's maids (Mrs Brown being the suffering mother of my beloved Buster Brown of the American cartoon.) Mrs Tina was a terrible snob, had photographs of royalty on her grand piano and sang Tosti's *Farewell*. For some occult reason she saw herself as a *grande dame* far higher up on the social ladder than all the other Whitakers.

The Joshuas were the ones I knew the least, so I always felt confused as to the number of their children. There was Hugh, who died at Gallipoli, and several girls. Josh I scarcely remember, but the little plump Victorian figure of his wife, Effie, is vivid in my memory: for she both fascinated and astonished me. Little wonder . . . because wherever she went, on a visit, shopping, at the opera or walking in her garden, her parrot went with her. A big green and red parrot perched on her gloved hand like a falcon. In some curious way that little fat left hand also managed to hold a silver snuffbox full of seed. The right hand leaned on a cane, that I suspect she didn't need in the least. This bird had become so much part of the local lore that the Palermitans, in order to distinguish Whitaker from Whitaker, referred to them as Whitaker Malfitano, Whitaker Villa Sofia and Whitaker Pappagallo (parrot). And thus they were marked in our family telephone book.

Mrs Josh was a great tennis player. In her beautiful garden at Sperlinga, famous for its roses, there were three tennis courts known as Hell, Purgatory and Paradise. Only a very few élite were admitted to play in the celestial court, while people queued for Hell and got into Purgatory by previous appointment. All this, of course, may not be quite exact as I was too young to come

near any of the three courts, but this is what I remember over-hearing from grown-ups' conversation.

However, at one point my sister, who had been taking tennis lessons, was, by very special favour, permitted to exchange a few volleys with Mrs Josh. The parrot was carefully parked on a chair in solitary splendour. It was to be a very brief encounter, because Effie instantly recognized the limited scope of Maria Felice's artistry, and quickly threw away her racquet exclaiming, 'This child has no more talent for lawn tennis than the cat!' And that was the end of my sister's career at the net. We were still allowed to go to her enormous garden parties though, as Grand-mamá was a very good friend of Effie's.

Sometimes we were also taken to garden parties at Malfitano, which, in Tina's eyes, were more elegant and sedate. There were always good reasons for them, either some minor royalty had appeared or the British Fleet or merely Lord and Lady Something passing through. To me the best part of Malfitano was the dogs' cemetery in a corner of the garden where I used to visit the grave of little Taffytoo, a bad-tempered little beast whom I had known well.

In those days, garden parties were the fashion and the Sicilian climate was perfect for such leisurely activities. A pretty sight they were indeed, ladies in light colours with boas, veils under enormous straw hats, gentlemen with their boaters under their arms and a few cavalry officers thrown in. Lace parasols against a background of palm trees and cypresses and long tables covered with white cloths spread with pyramids of strawberries and every sort of ice cream.

But it is time to go back to the dear Villa Sofia and its inhabi-tants, Mr and Mrs Robert Whitaker and their two daughters. Robert was a jovial, stoutish man with a jolly countenance and a little pointed beard. He collected stones, remained till he died one hundred per cent British, spoke fluent Italian with an accent and Sicilian without one.

His twinkling blue eyes, his button of a nose, his pink lips, in

fact all his face seemed to be set into a benevolent yet slightly satirical smile. He was justly famous for his sallies, or rather witticisms. Once at dinner, noticing a look of dismay on my mother's face as she contemplated her soup, he reassured her by saying, 'Don't be upset, Caroline, it isn't a hair in the soup but one of cook's lashes: she sheds them, you know!' Another time during a little dance, in fact, my first evening party, as we were merrily dancing around he suddenly stopped the music (in this case an upright piano), gathered us around him and uttered these memorable words, '*S'io fossi a casa vostra, andrei e case mia*' (If I were in your house, I would go back to my own house) . . . and the party was over.

His wife, la Signora Maud, was good-looking and, to my young eyes, the quintessence of feminine elegance – pastel colours, soft furs, toque hats, violets and, if she didn't, she should have smelled of Floris's Ormonde. In the house she wore vaporous teagowns and somehow she remains in my memory as being always enveloped in yards and yards of tulle and bedecked with yards and yards of small pearls.

Eileen, the eldest daughter, was grown up and therefore had little or no part in the everyday occurrences of our world, but the youngest, Beatrice, or Boots, as she was nicknamed, was the enchanting and enchanted creature who contributed more than anyone else to make my childhood the beautiful world that it became.

Dearest Boots, with her blue-grey eyes, her pale blonde hair and that sliding walk that made her look as if she had silent little wheels under her pumps. Oh, the rapture of late afternoons up in Mrs Goodman's room (she had been their nanny), lying on the carpeted floor playing with a huge Noah's Ark from Nuremberg, coal fire in the grate and muffled sounds from below, dreading the moment when one of these sounds should materialize into the summons to go home.

Boots always wore a little gold pin from which dangled a pair of tiny rose diamond boots, but her nickname had nothing to do

with footwear; it was a contraction of the Sicilian word for little baby, *bebuzza*, invented by her local wet nurse.

The house was a nineteenth-century Italianate villa bulging with terraces, piered windows, loggias, columns and turrets. It stood in the middle of a vast garden full of semi-tropical trees and rare plants, complete with gazebos, summer-houses and a paddock. But as soon as you walked through the front door, there was no mistaking the fact that you had entered an English house. Everything from the grandfather clock in the hall, the oak staircase, the papered rooms, the innumerable knick-knacks, to the club fenders spelled Britannia.

I first went to London much, much later when I was quite grown up, but the lingering remembrance of the atmosphere and the very smell of Villa Sofia made England instantly familiar to me. There were but a few lapses in this British orthodox decor, such as the mysterious presence on the staircase walls of some priests' vestments and a life-size Madonna and child in the dining-room.

Boots, Maria Felice and myself had a world of our own in which no other child or grown-up was admitted. One secret game was our favourite. It was played in the box-room, a large room filled with cupboards and huge wooden boxes where linen, blankets and furs were stored; there were no windows, and a strong smell of moth-balls pervaded all, giving it a sense of mystery and forbiddenness that appealed to us immensely.

Here, we played *Colisebo*, which was our secret word for Coliseum. As we were only three, there were an equal number of roles – Nero, the lion and the Christian martyr. Of course it was best to be Nero and all three of us wanted to play him because of the thrilling moment when the lion, turned for a moment into a victorious gladiator, would ask if he had to kill the Christian and the Emperor Nero, with a cruel look, would turn his thumb down. The lion was also a rewarding part, but none of us ever wanted to be the hapless Christian who never had a chance. I, being the littlest, nearly always had to be the martyr. Only once

or twice do I remember being allowed to play Nero looking through his emerald. As for the lion, both the girls said I was too rough and pulled their hair.

We had other favoured diversions. *Tableaux vivants*, theatricals and playing house in a little cottage that was Boots' own private property near the paddock in the garden. There, we were allowed to boil eggs – I have nurtured a hatred for hard-boiled eggs ever since – and toss pancakes. Theatricals were my joy as I loved acting, but my sister hated it, applied passive resistance and it had to be given up. Alas, here again, being the youngest, I was only given small, insignificant parts. In *The Love Potion*, I had to come on eating an apple and, in spite of being warned just to pretend to eat it, out of sheer nervousness I swallowed a big chunk of it and choked. Other plays were *Le Poète Seraphin* in French and a strange opus, also in French, set in the American far-west, complete with Indians. It began on a telegraphic outpost with these words uttered by some Whitaker cousin of sorts with the most appalling English accent: '*Ah quelle vie que celle d'un employé télégrafique.*' I, to my frustration, never appeared in person but only made Indian noises backstage.

On another occasion, this time in summer, the stage had been set in the garden, with refreshments at Boots' cottage, and we sang and danced:

> *Mit then Handshen clap, clap, clap,*
> *Mit futshen tap, tap, tap.*

from *Hansel and Gretel*, and I delivered a monologue called *The Fatal Pancake* that was quite a shocker (in it I had to belch and finally rush off-stage to be sick). But my great triumph was the rendering of 'Yip ˄v addy ay' after the final curtain of *The Love Potion*, though, to my shame, I was still wearing the pale blue Greenaway suit with patent leather belt and tam-o'shanter with a tassel from *The Love Potion*. Not in the least suitable for a saucy number with high kicks. They should have made a special costume for me.

As for Boots, we saw her in a gilt frame posing as Reynolds' *Age of Innocence*, Guido Reni's *Beatrice Cenci*, *Circe*, with a wand and a couple of stuffed animals, and *Bubbles*, minus Pears Soap. I cannot say enough how much I enjoyed these theatricals. I tried very hard to persuade Grandmamá to have some at home, but as Maria Felice hated such amusements, which she considered far too frivolous, I never achieved my purpose.

In those faraway years, a novelty, recently imported from the carnival at Nice, was a 'Battle of Flowers' or *Corso di Fiori* as it was called in Italy. The *beau monde* of Palermo would set out in victorias, landaus and some of the first motor-cars, all adorned with flowers and greenery, and head for the 'Giardino Inglese'. This was not an English garden at all, but a long, broad avenue lined with plane trees. Its real name was, and is, Via della Liberta but it was never referred to by this name. Once there, they would parade around throwing little bouquets at each other. A more childish or innocent game cannot be imagined. I remember a memorable 'Battle' held for the Emperor and Empress of Germany. We were in a landaulet covered with wisteria and pale pink carnations. A prettier sight would be hard to find: slowly-moving floral vehicles filled with gaily-clad ladies with their enormous hats and feather boas and children in their Sunday best. The greatest beauty of her day, Donna Franca Florio, in a bower of red roses or the Princess of Trabia, also very beautiful in her quiet way, in a victoria of forget-me-nots. We children, of course, became very excited and when we crossed another carriage full of friends the exchanges were quite violent. Sometimes there were casualties, like hats knocked off or a feather boa let loose. I was teased for years after because, it was said, I had thrown a rose at the Kaiserin with such violence that, when she passed again, she was holding a handkerchief to her face. (I wish that story had been true and that the rose had been something heavier and aimed at her spouse instead.)

Prompted by such exalted examples, Boots organized a Battle of Flowers at Villa Sofia. Maria Felice in solitary splendour drove

her pony, Nini, in a carnation-bedecked *tonneau*, and Boots and I bowled along in a Sicilian cart adorned with cornflowers and daisies. It turned out to be a fiasco, for it wasn't much fun to throw flowers at each other under the vacant looks of parents and governesses.

We also had fancy dress parties each year. There must have been a craze at that time for grown-ups and children to dress up. Extreme care was taken by both Grandmamá and Mamá with the costumes. Periods were discussed, books consulted and seamstresses summoned. Sometimes costumes were bought in Paris in October, at the Nain Bleu. I despised them because they lacked invention, and it was rather oppressive to think that, come what may, I would be made to wear what had been bought. Thus, I reluctantly had to be an Indian or rather a savage of some unidentified habitat, in coffee-brown *maillot*, multi-coloured feathered head-dress and kilt, leopard-skin shield and papier mâché club that split in two on the head of my friend, Alessandro. From the same source, Maria Felice had a complete *cantinière* with a little kernel and a barrel. There are still faded photographs of myself posing dejectedly as a jester, an Arab sheik and so on.

One year Countess Mazzarino gave a grand fancy dress children's ball in her enormous and very beautiful palace. The most elaborate costumes were chosen. Fabrizio and Lucia, the young Mazzarino hosts, were dressed as the children of Charles I by Van Dyck. Sofia Trabia (now Princess Borghese) was Diana in a green tunic, and her sister, sweet Giovanna, who is now married to my cousin, the Prince of Paterno, was a rose. Her brother, Manfredi Trabia, (who was killed during the First World War along with his brother, Ignazio), was a most striking crusader. Igiea Florio had been dressed as a ballerina in a pink tutu, but we never saw her, we just heard her, because she set up such a tantrum that she never entered the ballroom at all and had to be taken home. Grandmamá had the idea of dressing up my dark and reluctant sister as the Tulip in Grandville's *Les Fleurs Animées*. Each petal of taffeta was painted by hand. The head-dress was a

kind of turban, also hand-painted. I went as 'Incroyable' of the French '*Directoire*' in a redingote and gilet made out of eighteenth-century silk, and complete with a 'cocker spaniel' wig; tight pants, extremely uncomfortable to dance in, dangling fobs and a jabot. To complete the picture, a beaver bicorne was perched upon my head, or rather on my cocker spaniel-eared wig, and in my hand was a crooked cane, not unlike Harry Lauder's. In fact, I shouldn't have gone at all as I was running a temperature, but such was my determination that I wore down all opposition.

In spite of all these splendid preparations, the ball ended in great disappointment. For days ahead it had been arranged between Giovanna the Rose and poor little me that we should dance the cotillon together, but to my dismay and rage (eyes beginning to smart, but mustn't make a fool of myself) I was told that the Rose was going to dance with our young host, alias the Prince of Wales, and that I had been allotted Diana, with her bow and arrows, sandals and crescent. Diana, of course, noticed my disappointment and was in any case very much displeased herself: she snubbed me all through the dance. Thinking back, I realize it was probably just a sordid question of height, as even then I was small for my age and so was Sofia. But I could only think in terms of jealousy and love and I didn't forgive Fabrizio Mazzarino for quite some time.

It is amazing to think what a large place these festivities took, not only in our lives, which was only natural, but also in those of our parents. Every detail of the costume was discussed at length, once the style had been decided. Books were consulted and advice sought. All this was just Grandmamá's cup of tea: she possessed a vivid imagination and loved planning. Mamá meekly followed suit, but in her quiet way tried to restrain her mother's flights, reminding her that children had to be able to move in these artistic concoctions. Poor Maria Felice, who was the victim, was very down-to-earth and rather despised these shenanegans: she hated having to stand still during interminable fittings.

One autumn we had been in Paris for the state visit of King Sisovath of Cambodia. He was a very colourful personage and we had seen him coming out of the Elysée Palace. But what had taken the Parisians by storm was the fact that he had brought his private dancers with him. The shops were full of china dolls of all sizes, dressed in Cambodian ritual dancing costumes, golden, pagoda-like head-dresses, bouffant bloomers and upwards-pointing epaulettes and slippers. So, of course, the following winter, at a party at the Villa Sofia, my resigned sister was dressed as a Cambodian dancer. They even tried, in vain, to make her move her fingers rhythmically (she flatly refused to wear the long metal fingertips, saying that she couldn't blow her nose).

At this same party a great and dear friend of ours was attired as Joan of Arc, after the Ingres painting, *Jeanne d'Arc au Sacre*: her costume of full armour was made out of tin by the famous Sicilian puppeteers. As she was coming up the stairs, with a noise like several kettles being dropped at once, the poor girl crumbled and couldn't get up again without the help of her governess, our Miss Aileen's sister Alice Brennan.

Theatricals and fancy dress, balls, parties and visits to friends made the winter evenings of my childhood fly past. Every summer we would tour the continent, Boots would go to England, other friends would visit relatives and we would all lose track of each other. But one of the joys for me of coming home in November was being able to show off whatever I had acquired during my travels and to see what novelties others had brought back. Another great joy of returning to Sicily was the freedom to race about and space to do it in after so much hotel life. In my memory, places stand out more strongly than people and possessions: I cannot remember all the toys I possessed nor the games I played, nor can I always visualize all my childhood friends with great clarity, but I can remember their gardens.

I have talked of the delights of the garden at Villa Sofia, realm of my dear Boots, but there were other gardens in the world of my childhood. Terre Rosse, the garden belonging to the Trabias: a

stately gateway, a long avenue of trees. a *parterre* and, beyond it, a low, baroque *palazzina*. The gardens around were vast and, to me, full of mystery; there was even a tunnel that passed under the avenue allowing me to go from one side to the other without being knocked down by the Trabia boys' gymkhanas and bicycle races. I was too young to take part but would pedal away by myself on a little tricycle, while the girls were placed at strategic points to see that no irregularity was committed. The whole proceedings were supervised by the very competent and ladylike Miss Russell, who was Sofia and Giovanna Trabia's governess, a dainty figure with minute features and an engaging smile. We all loved her and went on doing so, because she remained long after the girls had married and was a great comfort and help to Princess Trabia through the tragedies that were in store for that family so dear to us. She died, as she had lived, smiling, silent and ever-vigilant.

The Mazzarinos also had a garden quite near the Villa Sofia. There was no house but, if I remember well, some kind of kiosk. In fact, it was more like an arboretum with all kinds of strange plants. The main attraction was the *victoria regia* growing in a lake. Its leaves were so big and sturdy that a light person could stand on them: I remember seeing a photograph of the exquisite Vivina, the eldest of the two Mazzarino girls, sitting demurely on a chair on one of these leaves.

Then there was the garden of our strawberry-blonde friend, Anna. Her father was the Prince of Camporeale; her mother, Florence, a beautiful American, had never quite mastered Dante's language. Anna, an only child, only too eager to have company, invited us quite often to play in her garden. You descended into it from a verandah and the effect was that of a distant, oriental grove – green shadows, tall, thick trees, palmettos and bamboos. A perfect setting for rough games, but it was difficult to indulge in them under the watchful eyes of the governesses sitting on the verandah.

Of course as we had the enormous Favorita park at our disposal,

we utterly despised the city's public gardens filled with pallid children making little sandheaps. The Villa Giulia was a formal, pretty garden, with a big classical gateway on the Marina adorned with a multitude of vases and urns. Its great attraction for children was a venerable old orang-outang, but, in spite of our city friends telling us about the charm and cunning ways of 'Bernando d'a Villa Giulia', as he was called, we never wanted to make his acquaintance as we were content with the baboons living at the bottom of our own garden. The Botanical Gardens were far more select, as you needed some kind of a pass to enter them, but I don't ever remember going there more than once or twice. These gardens, however, remain vivid in my memory, not for the rare plants and trees but for the exquisite entrance pavilion, very *retour d'Egypte* – its sphinxes and lotus-shaped capitols absolutely fascinated me. As for the Giardino Inglese, this provoked our scorn. Every time we drove to or from town through the Via Liberta, we had to pass between it and the even-worse Giardino Garibaldi, dwarfed by the larger-than-life, bronze statue of the hero of the two worlds (so named because he had also fought in South America for the cause of independence), sitting on his charger pointing a menacing finger towards the town that he had supposedly liberated. We never dreamed of setting foot in the English garden. What we saw beyond the railings was quite enough: sad-looking trees, busts of famous people, cement walks and a bandstand in the distance. I felt sincere sorrow for those poor town children, whose only chance of being in the open air was restricted by opening and closing hours and who had to share the small space in which they could play games with howling, unweaned babies and their wet-nurses, maids flirting with new recruits and, horror of horrors, dogs on leashes.

So when everything was said and done, it was always with the greatest joy and satisfaction that I came back to our dearly-beloved garden at the villa. It is only in his own garden that a little boy can unfold himself completely. He can climb trees at

leisure. He will not be forced to play the games his host wants to play, causing him to resort to sulks or even open battle. As he knows every nook and cranny of the terrain, he can easily get lost and pretend to be out of earshot of the voice of authority. Oh, the thrill of being way up, hidden amongst the leaves of a tree, while down there someone is looking for you; then, when the coast is clear, to clamber down and gallop to another part of the garden which you know has already been searched, and when the moment of discovery comes at last, to answer the exasperated 'Where have you been?' with 'Nowhere, I've never moved from here. . . .'

It is very difficult, nay impossible, for me to try and put into some chronological order the events and personages of those faraway years that go from the turn of the century to just before the First World War. It is, in fact, like closing up a telescope and reducing the various distances of years into a dream-like and luminous nucleus in which seasons, emotions, dear faces, laughter, a little naughtiness and a few tears keep revolving, without an ordered sequence, before the eager brown eyes of the little boy that was I.

When foreign royalty came to Palermo in their yachts, one of the monuments to visit was the Chinese *palazzina*. They came through La Favorita and halted at the roundpoint about a hundred yards from our gate. There Grandmamá, Mamá, we children and Miss Aileen, all wearing our best finery, would be waiting, with Maria Felice sulkily clutching the bunch of flowers ('Don't hold them so tight, they won't fly away!') she had to present with a curtsey. The Germans came several times and I was, after much baiting, terrified that the Kaiserin might recognize the child who had scratched her face with that fatal rose. (As I have said before, this rose-throwing incident never really occurred but, because I had been teased so much about it, I ended by firmly believing it.)

Once Empress Eugenie, all in black, stepped out of her open victoria to receive the flowers and the deep curtsies of my ladies. Maria Felice got a kiss and I a friendly pat on the cheeks. She

seemed to me frail and small. Her eyes were made up and very sad. Or did they seem so sad because I had heard her story and knew Carducci's splendid ode on the death of the Prince Imperial? We were to see her again at a great reception and were very much impressed when, after having said good-bye to the assembled guests, she went towards the door with her host and hostess and, before leaving the room, turned around and curtseyed, *à la ronde*, including everyone in this charming gesture.

King Edward VII and his Queen also came to our shores, creating, I am sure, hysterical excitement in the clan Whitaker, battling by fair or foul means as to who would get them first. The King was pink and round, suggesting Humpty-Dumpty wearing a grey felt egg-cosy. Queen Alexandra was beautiful, rigid and glazed; her head, hair, hat and veil seemed to form a single entity which appeared impossible to separate.

Grandmamá led a very quiet, rather retired life and Mamá didn't care for social life at all. Once a year Mamá went to a charity ball which was held at the Excelsior or the Villa Igiea; but she only went because her mother was the patroness. She had a list of people to whom tickets were to be sent and once had one returned by a gentleman who stated that, having been paralyzed from the waist down for the last twenty years, a ball, even a charity one, was the last kind of outing he was likely to attend. The ball was always a memorable occasion for us, because the next morning, sitting on Mamá's bed, we were given all the favours and presents and listened, enraptured, to her descriptions of the previous evening's splendours. It seems that Mamá was a very good dancer, but somehow I couldn't imagine her whirling around in some gentleman's arms. When the era of the *thé dansants* reached Palermo, we went to one given by the Princess Trabia. I was somewhat intimidated and so I sat in the corner with the Trabia girls and the two younger Mazzarinos. After a slight pause, the orchestra began to attack a waltz; the first couple took to the floor and started revolving faster and faster in a flurry of feathers and skirts. When I realized that this dervish butterfly was my mother in the tight

embrace of a moustached black beetle, I burst into inconsolable tears making an utter fool of myself. Mamá stopped and tried to console me; everyone thought that I was a little darling to be so tender-hearted. As a consolation, the next dance, which happened to be a mazurka, was announced as being specially for the children. Lucia Mazzarino and I attacked this Polish dance with such vigour that we both fell and rolled into the middle of the room to everyone's amusement. Mamá had the last word: 'I, at least, didn't fall.'

At dancing lessons and parties I spent most of my time talking and playing with the children I knew best, the Trabias, Mazzarinos, Florios and, most beloved of all, the Whitakers; I felt that Boots was my particular friend. Our other neighbours were the Gebbierossas, or the Gebbies, as we called them. They lived a few kilometres away from us on the other side of San Lorenzo village in another beautiful eighteenth-century villa. The family consisted of father, mother, three boys and a German governess. Father Peppino was of simian appearance and bow-legged, but a good and kind man; mother Maria was erect, unsmiling, oozing virtue from every pore, her long nose seemed to be perpetually occupied in ferreting out other people's deficiencies. The boys were called Alessandro, Luigi and Amedeo. The third was too little to be of any interest to us. The governess was a formidable and tightly-corseted female. Her name was Fräulein Mittinger, she came from Friedrichshafen, had known Graf Zeppelin and spoke of little else.

Alessandro was just one year older than myself and was my 'official' best friend – I say official because we were literally thrown at each other by our respective families. But as the years passed I began to be more and more irritated by the comparisons of his achievements with my own imperfections. To begin with, he was growing taller than I and kind relations and friends never allowed this fact to pass unnoticed, which exasperated my mother. He was also better than I at practically everything except swimming and climbing trees. We had the same teacher, the earlier-mentioned Miss Twins. Every time I was slow at my lesson, she told me that

THE HAPPY SUMMER DAYS

Alessandro had learned whatever it happened to be in no time at all. He was always neat while I was often dishevelled and grimy. Like a well-trained dog, he did exactly what he was told to do, and did it well. I finally resolved that something had to be done about it.

Nearly every Sunday we went at eleven o'clock to their private chapel, where the two eldest Gebbie boys served mass. By means of passive resistance, I had managed to avoid doing it myself as I thought it to be beneath my dignity. But Alessandro and Luigi, who was a good-natured, little blond boy, did it very well, answering in perfect Latin, pouring the water and the wine without spilling a drop. In other words they had become two perfect, downcast-eyed acolytes. This perfection had to be disrupted somehow, so Maria Felice and I thought up a diabolical plan that turned out to be a most rewarding experience.

That summer in Paris, we had visited a shop called Au Rire Gaulois, which sold all kinds of jokes, bleeding bandages to slip your finger in, blue rubber blots that looked like spilled ink and little cushions that made a rude noise when you sat on them; there, we had bought some small round boxes containing itching powder. Through some stratagem that I cannot remember, we managed to drop some of this powder on to the salver, the napkin and the two vessels of water and wine. As the boys had to arrange these objects before the mass began, they were already scratching themselves by the introit. The officiant was a certain Padre Trupiano, who was Father Confessor to both our families and was called by us 'the Handsome Priest', because once, on seeing him for the first time, Miss Kay had enquired with clinical curiosity, 'Who is that handsome priest I saw walking in the garden?' He was a tall, robust man who stood no nonsense. He was soon aware of the boys' curious antics and, between '*Dominus vobiscum*' and '*et cum spiritu tuum*', he darted fulminating looks in their direction, with no effect whatsoever, as by now they had spread the fatal powder all over their faces, necks and legs, and the itching had increased. At one stage, as Alessandro was passing the missal from

147

THE HAPPY SUMMER DAYS

one side of the altar to the other, the priest rapped him fiercely on the knuckles, causing the poor lad to let out a timid yet audible yelp. By this time, their mother and Fräulein Mittinger had noticed that something was very wrong and their growing uneasiness had communicated itself to the rest of the small congregation. Grandmamá, kindled by her anti-clerical feelings, eagerly awaited further developments, while Mamá, utterly bewildered, sought refuge in intensified prayer. Then came the moment when the priest wiped his hands on the cloth and also started itching. This we had not anticipated.

I don't know how the mass came to an end without a major explosion, but never was one concluded at such a pace. It became a sort of liturgical Grand National and the litanies after the *ite missa est* took on the allure of the *William Tell* overture. After it was all over, the congregation trooped out, some puzzled, some incredulous and some of us highly satisfied. What happened to those two unfortunate children I don't know. They stayed behind in the chapel and I suppose got their ears boxed. We did not see them again that day.

It all came to nothing in the end. The Gebbie parents were too righteous to admit that there might be any shortcomings in their paragon offspring: we had taken good care to blackmail those gutless children into silence. The whole operation had succeeded just as we planned and got away with it, which was both immoral and highly satisfactory. Incidentally, it is amazing to consider the amount of deceit and cruelty that goes on between children. We must indeed have been rather horrible when young, always good to animals, but with little consideration for other human beings.

There were some distant relations who used to come once in a while to the villa, usually during the Christmas or Easter holidays. The girls, three pallid, tremulous creatures, were afraid of practically everything, and the boys, also of the pale, open-mouthed variety, were sick after any excitement. These were fertile grounds for my imagination and I seldom refrained from making the dogs go for them, obliging them to hold the monkey or chasing them

with a cockroach in my hand. Their visits to us must have been
real torture for them. Of course, as we grew up, they became our
most intimate and beloved friends! We also saw, though not very
often, another second cousin of ours, whom I only mention
because he became, much later, the author of an admirable if
historically incorrect book. Giuseppe Palma, later Lampedusa,
was an only child. Son of a brilliant and vivacious woman, he was
the complete opposite: fat and taciturn, with big, sad eyes, ill at
ease in the open air, timid with animals. I could never have
imagined that one day he would become the author of *The
Leopard*, in which, by the way, Tancred and Angelica are supposed
to be fashioned after my grandparents. I say 'supposed', because I
found many discrepancies; but, after all, it is the privilege of the
author to alter facts when writing fiction.

The relations we loved the best were the Paternos. Mother's
eldest sister, Caterina, was married to the Prince of Paterno and
they were the parents of our much-loved cousin, Maria Giulia.
The eldest boy, Ugo, was much older than me, so I saw little of
him: he had once organized a circus at the villa, which I only
vaguely remembered, but for years I had to listen to accounts of
his memorable feat. He eventually married Giovanna Trabia, the
rose of the Mazzarino ball. The youngest of the family was
Corrado who, for some mysterious reason, was known as 'Boy'.

In point of fact, we lived in a small, very select, world of our
own and few were the outsiders admitted within its boundaries.

11

THE MOMENT HAD TO COME, and it seemed far too soon to me, when I had to go to some sort of school. I had never been to any kindergarten or what was called in Italy (and I suppose still is) the elementary school. As you may remember, I was taught at home by the Signorina Gemelli (Miss Twins). I also went to the Ursulines where I learned to draw and recite *La cigale et le fourmi* and *Le renard et le corbeau*. These Ursuline nuns had taken refuge in Palermo when, under a wave of anti-clericalism, they had been expelled from France. The Mother Superior was a wonderful woman, greatly respected by my mother. I had my first communion in their little *villino*, which they had turned into a convent, and learned my catechism in French. All this was nice and easy, but now, as I was past the elementary school age, I had to tackle the gymnasium, five years of Latin, maths, history, geography,

etc., etc. In spite of what they may think and say in republican Italy, those were days of a real democratic way of life. If you didn't want to put your children in a Jesuit school or in some lay college, the only alternative was the communal school in the town where you lived. So I was entered for the Ginnasio Garibaldi on the Via Maqueda. A new era began from that day.

Every morning, bright and early, I was taken to town in what was known as the kitchen carriage on its way to the market and dropped off at the door. The first day was terrible. I felt frightened self-conscious and utterly mystified. In a few short hours, the enchanted world into which I was born and was growing up began to totter and crack. I began to realize that this planet did not consist only of beautiful gardens, peopled with dear friends and friendly dogs, or large, beautiful houses in which everything seemed to be there to make you feel warm and secure. Instead, here I was seated at an ink-stained desk in a whitewashed, rather shabby room with twenty or thirty pairs of eyes scrutinizing me. That first day I had been accompanied by Mamá and they had seen me step out of a private carriage with a liveried footman opening the door, a grave mistake that was never repeated. Facing me behind a raised table, a bored teacher kept scribbling God-knows-what on a stack of papers and, from time to time, accurately launched sonorous jets into a large spittoon. Eventually, as a first exercise, we were made to write our names on the blackboard, one by one. When my turn came, I wrote Fulco Santostefano, omitting all the Cerda and Verdura trappings, as I had been instructed to do – in consequence, for the first few days, when I was addressed as such, I couldn't think who they were talking to! Two days a week there were morning classes only and I was able to go home for lunch, but on the other three days Nicola or someone had to come to fetch me and take me to Casa Verdura for a snack. At three o'clock I was taken back to Villa Niscemi by carriage, if convenient, or by tram otherwise. I much preferred the latter means of transport as it was such a novelty, especially when, for some unavoidable reason, I had to do it on my own.

The first weeks of school were torture and I hated every moment. This so-called seat of learning seemed to me a very squalid affair: long, gloomy corridors lit, even in daytime, by electric bulbs hanging from the ceiling, a faint smell of disinfectant permeating everything. The upkeep of this inhospitable building was in the hands of two or three *bibelli*, a strange race of individuals who were found in schools all over Italy. Usually veterans from some war, they were lame, one-eyed or otherwise maimed and, to distinguish them as employees of the state, they wore military-looking caps with royal crowns on them. Their arm was an antique broom and their idea of cleanliness was to empty buckets of water over the floors, sweep it into every nook and cranny and leave it to dry by itself. As this operation happened first thing in the morning, it was wet as a ricefield when we got there.

My classmates were totally unknown to me. I didn't know where they came from and their names meant nothing to me. They were of two kinds: the pallid, taciturn ones with running noses, and the truculent, bossy ones with bad manners who talked 'dirty' and seemed to me to be both supercilious and suspicious. The first species did not count, they seemed unhappy in themselves and only woke up when, at the end of the classes, they could see the reassuring faces of their mothers waiting downstairs to take them home. But the second lot really unnerved me. They asked indiscreet questions which I didn't know how to answer because I didn't even know what they meant. Their parlance baffled me and their practical jokes made me blush with embarrassment. I had to pretend, for instance, not to know French, which I spoke far better than the master, so as not to be the butt of their Gallic salaciousness. The worst torture of all was to have to use the smelly 'Gents' at the same time as others. I was an extremely modest little boy in such matters and used to die of shame and mortification.

Up to these first, miserable school days, it had seemed to me that my happy little world would stay forever, or rather I didn't

see how or why it should ever change. The same unfolding of the seasons, the same reassuring familiar voices, Christmas, the days getting longer, Easter, May, June, sea-bathing at Mondello, the excitement of travelling and then coming home and being reunited with my beloved garden. Then there were our birthdays and the Saints' Days, when we were allowed to order the dinner menu: profiterolles Marie Louise for Maria Felice and Mont Blanc for me. I was one of those children, and I suppose there still must be some like me today, who had absolutely no thought for the future, no haste to grow up and no curiosity at all about the mysteries of life. Perfectly content with my condition, I would have liked everything to stay the same forever. It is only now, after so many years, that I can define my inner thoughts: in those days I simply didn't think, being busy living my little life and enjoying every moment of it.

However, little by little, I began to change. I started to enjoy some of my new experiences – even if they were still Chinese to me, I was at least beginning to understand. Some of the children at the school wore shabby clothes and their shoes were down-at-heel, while others were very smartly dressed. My heart went out to the former and I began to be ashamed of my nice Peter Robinson sailor suits and my dapper little coat with its brass buttons. After long discussion and much pleading, I was at last allowed to wear at school what I wore at home, a turtle-neck sweater and last year's trousers. Neither Mother, sister nor governess were allowed to come anywhere near the Ginnasio Garibaldi and if, by any chance, they happened to pass by when I was with one or two of my new friends they had to go on walking and pretend they had never seen me before. In June I had my first exams. They were a disaster. Typically, instead of blaming me, the family (for once my parents were of the same opinion) blamed the school and I was transferred to the Umberto I, a much larger and just as squalid school situated in an ex-Benedictine convent where I continued for years to struggle with the art of learning. In fact I was still at it when, at the end of 1916, I volunteered to go into the

army (not from patriotism, but because I wanted to be an officer) and found myself after eight months on the Austrian front. Only four years separated my magical existence in the garden from the horror of Caporetto. But that is another story and doesn't belong to this book.

Maria Felice was growing up. She was becoming quite pretty with her dark, luminous eyes, but she remained child-like and her principal interests were still the animals. Meanwhile, I was discovering that a pencil was a thing I could use to draw whatever I saw or whatever went through my mind.

That year the winter had been very mild. The almond trees had shed their blossom and the sweet scent of the *zagara* was beginning to come in through the open balconies. Grandmamá seemed to be more silent than usual. She had ordered a motor-car which was supposed to be delivered in a couple of months – to the great indignation of Gnu Antonino – and Blasi, one of the younger coachmen, was taking driving lessons. The harness-room was being changed to make room for the car. My Sicilian cart and Maria Felice's *tonneau*, which had been kept there for years, were dislodged ignominiously. In fact, all of the courtyard was undergoing a change before the advent of the horseless carriage. Mamá was preoccupied, she had long, muffled conversations on the telephone, and one day, as I was joining Maria Felice in the garden where she was feeding the goldfish, I noticed that she had been crying. When I asked her why, she only said, 'You will know soon enough.' This puzzled me a great deal. Nothing had happened to upset her. All the dogs were in perfect health and none of our friends, that I knew of, was ill.

Finally one afternoon, coming home from school with Mamá, as we were going through La Favorita park (I can still see the box-edged road, the racecourse on the left, and on the right, pink in the glowing sunlight the looming Monte Pellegrino), she took both my hands in hers and said, 'Have you ever thought of what you want to do when you grow up?' As I remained silent, she went on, 'There are going to be some great changes in our lives

very soon, your grandmother is dangerously ill and might die in the near future. We will have to leave the villa and probably go and live at Via Montevergine in Town.' I was chilled into silence. She continued, her kind brown eyes searching mine, 'Would you like, if we can get you in, to go to the Villa Mondragone school at Frascati, or the Quercia near Florence, both are supposed to be very good?' I began to realize then that the world as I had always known it, my world, was going to disintegrate, evaporate, or rather, which in a way was worse, fall into small pieces that could never be put together again. The dear voice went on, 'You will have to decide about your future. The army, like your father? The navy? Your Uncle Alessino, who died before you were born, went to the Naval Academy in Leghorn, or would you rather enter the Diplomatic Corps? You must begin to think of all these things. You see, you will not be very rich, in fact, you won't be rich at all and will have to choose what kind of career you want to follow.'

By this time I was trying unsuccessfully to make my chin stop trembling, but, as we turned at the roundpoint and I could see the big plane tree and the white gate, I could hold back no longer and burst into a flood of tears. Strangely enough, some kind of awed scruple restrained me from discussing this new state of affairs with my sister, and I think she felt the same way.

Everyday life went on, but in a lower key. Doctors appeared frequently. A specialist arrived from I don't know where. There were consultations in a certain room on the second floor, from which they emerged with grave faces. Now Grandmamá never came downstairs any more, she went from her bed to the chaise-longue in her little sitting-room where she received the few visitors she cared to see. Dear old Monte came often, advertising her own remedy to cure any disease: the use of an enema every morning, the *'frou-frou'* as she called it. Princess Gangi also came; she was Grandmamá's co-mother-in-law as her daughter, Beatrice, had married my Uncle Peppino. She was a delicate little lady who looked like a *blanc de Chine* and talked, or rather stammered, in

the most extraordinary way, mixing Sicilian with French, using Zs instead of Rs, saying, '*Cazo*' instead of '*Caro*' and '*Bonjouz*' instead of '*Bonjour*'.

I was only allowed in to Grandmamá's room to say good morning and good night. Children are very strange creatures indeed! I, who loved her, second only to my mother, now went to see her because I was made to, and was reluctant even to kiss her. Marie Felice saw much more of her, but even she had become strangely reserved.

In the garden, along the pepper tree alley, there were some ornamental lamp-posts. They were never used, but Grandmamá had always said that they would be lit on Marie Felice's eighteenth birthday night when a grand ball would take place at the villa. This ball had been part of our dreams for years. We had often discussed if it wouldn't be better to postpone it till late spring when it could be out of doors on one of the terraces. Could I invite my special friends, although too young? Would the so-and-so's be asked, would the dogs enjoy it? . . . and so on. One evening, the two of us were walking in the twilight, both immersed in our own thoughts. Suddenly Maria Felice broke the silence and, sadly pointing at the lamps, said, 'They will never be lit now, there won't be any ball.' We hugged each other very hard and, hand in hand, went back to the house with the dogs.

A pall of gloom seemed to be descending on all of us. Mamá seldom went out and spent her days trying to convince the invalid that she would get well again, that the doctors had said this or that, and even to urge her to make plans for the next trip abroad. All the same, as summer arrived, we started going to the beach once more. Our cousins from Rome had arrived and were living in their house in town, so sometimes we would go with them to a popular bathing establishment called the Acquasanta, situated in a rather dirty little cove, and take a boat to go and swim in front of the Villa Igiea.

By this time Grandmamá never left her bed. Except for one

last time. The motor-car had arrived, a tall, lugubrious-looking affair with brass headlamps. There was, of course, no question now of her ever driving in it. She, who had looked forward so much to this new addition, could only drag herself to the window to see it slowly revolving round and round the palm tree in the courtyard. We were asked if we wanted to take a tour in it, and we both refused. The household had decided that it looked like a hearse and, as such, brought bad luck. It was put aside and we never saw it again.

The house had become very silent. The dinners were especially trying. After the routine question from Mamá, 'And what have you been up to today?', to which we answered, 'Nothing much,' or 'The usual things,' the silence would solidify around us, broken only by the rattle of the knives and forks. Miss Lilley, our last, long-suffering governess had already left, and round the big table there were only the three of us. It was a very hot, sultry summer. At night through the open window where distant, noiseless lightnings tore the sky open, you could just see the everlasting sarabande of the bats zig-zagging through the warm air. The meal finished, Mamá would go upstairs to resume her vigil, we would try the terrace for a while and soon, driven in by the mosquitoes, go to bed to seek solace in sleep. That, I must confess, never failed me.

My poor mother was going through a terrible crisis of conscience. As I have mentioned before, she was a deeply religious person and she was suffering from the fact that her mother, whom she adored, had lost her faith, or so she said. Must she be asked if she wanted to make her peace with God, or should they pretend that she was going to get well? We were not told anything about all this, but I had of course noticed that Padre Trupiano came often and had long confabulations with Mother and her sisters. Once or twice he was shown upstairs, but he did not stay long.

August was over and September had begun with the same implacable heat. I was not allowed in Grandmamá's room any

more and was moved to another part of the house. Maria Felice, whose room was next to Grandmamá's, also had to move. Everyone spoke in whispers and seemed to walk noiselessly. We were not taken to the beach any more and spent our days aimlessly wandering about the garden, not even venturing into La Favorita. The doctors seemed to be always present, so was the priest. The maids hurried silently past us, bent on mysterious errands, and the dogs, panting in the heat, had lost interest in us because we had not paid any attention to them.

After three or four days, Maria Felice was summoned upstairs and, to my desolation, I was left alone. All the life of the house seemed to be concentrated on the second floor outside that room, or downstairs in the servants' quarters. In the late afternoon, while I was trying to take an interest in the antics of the old parrot in the entrance hall, Maria Felice came to tell me that the end was near, Grandmamá was unconscious and Mamá wanted me. She took me by the hand and together, without saying a word, we once more crossed those familiar rooms so dear to our hearts. The *Stanza del Telefone*, where we had our Christmas trees and our jigsaw puzzles table (I had always tried to hide one piece so as to be the last one to put in). The big drawing-room with its frescoes and innumerable sofas and armchairs. The green room that was not green, where the bear used to live behind the piano, finally through Tobias's room, where I was born, up the little winding stairs to the corridor that led to Grandmamá's room.

As it was still very warm outside, the persiennes were closed. In the semi-darkness I could guess, rather than actually see, who the motionless shadows were grouped at the other end of the long passage: the tall, standing figure of Padre Trupiano, softly reading out of his breviary, and three ladies, our aunts, sitting together whispering in each others' ears. From time to time, Aunt Caterina went inside and came back shaking her head, leaving the door ajar. We could see that, inside the room, the lights were on. Mother, looking haggard and rather dishevelled,

came out towards us, kissed us without saying a word, and
vanished again into the room. By this time, still holding my
sister's hand, I was sitting in a state of petrification, not being
able to move or say a word. In the back of my empty head, the
thought that I also might die began to materialize. A primordial
fear began to chill my spine. Behind us, the kneeling maids were
muttering prayers; against the wall, Angelo, the old butler, and
Pasquale, who used to be our courier, stood motionless. From
somewhere a clock struck the quarters. Time seemed suspended
but was, instead, running out. Our Uncle Peppino came out to
smoke a cigarette, but was promptly called back by Mamá. The
others also entered the room, one by one, on tiptoe. The Padre's
voice became louder: at last he went in too. Now, except for the
servants and ourselves, they were all in there behind that closed
door.

The state of mental paralysis in which I sat didn't allow me to
perceive what was going on. Silence and darkness were upon us,
nobody dared to move. Then a muffled scream shook me out of
my trance, the door opened wide and Mother was carried out,
half-fainting, and laid down on a settee. Nobody thought of
turning the lights on, the only glow came from the room where
Grandmamá lay dead.

Now that death had finally arrived, everything seemed to come
to life again. We rushed to Mamá, covering her with tears and
kisses; she soon recovered and instantly wanted to go back to
the room. Father and the other sons-in-law had arrived and were
waiting downstairs; someone had to go and tell them; orders
and counter-orders were given. Maids rushed in all directions.
We went downstairs to see Papa. He told us that we were going
to stay at Casa Verdura as soon as it was ready for us. I rushed
upstairs again to see how Mother was, but she was still behind
that door. All over the house people were talking; for the first
time I heard the word 'testament', little realizing that I would be
hearing it as a leit motiv for years to come. As one has to eat
whatever the situation, dinner was served. It was a confused

meal, as everyone was constantly getting up to use the telephone. Mother remained upstairs. Father, the uncles and the aunts left to return to their homes. The villa emptied once more. Mother came to kiss us goodnight and see us to bed. Outside, the weather had broken and it was raining very hard.

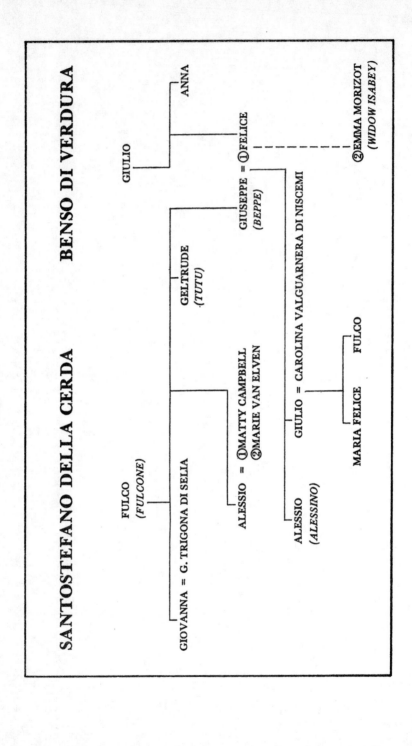

SANTOSTEFANO DELLA CERDA BENSO DI VERDURA

VALGUARNERA DI NISCEMI

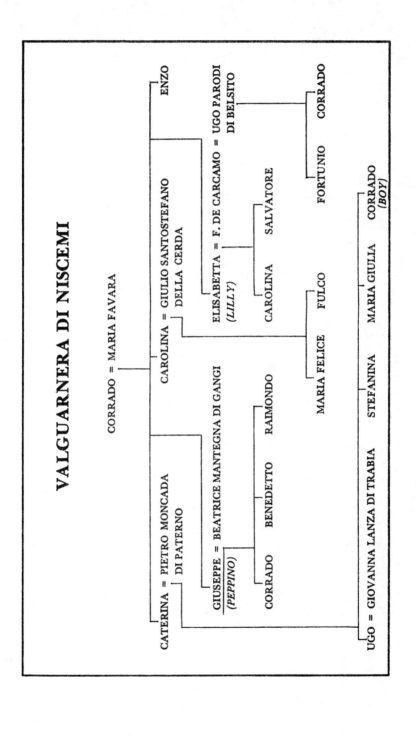